"FEEL THE BONDS THAT DRAW"

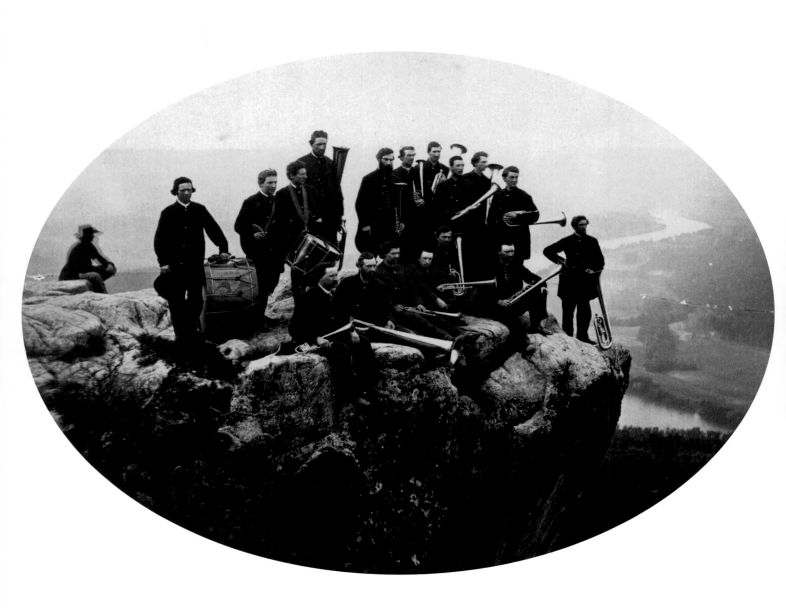

"FEEL THE BONDS THAT DRAW"

Images of the Civil War at the

Western Reserve Historical Society

CHRISTINE DEE

Published in cooperation with the Western Reserve Historical Society

THE KENT STATE UNIVERSITY PRESS Kent, Ohio

Western Reserve Historical Society and The Kent State University Press gratefully acknowledge the following foundations and individuals for their generous support of this book:

Leon Falk Family Fund of The Falk Foundation

Allen H. Ford

Donna and Robert H. Jackson

Betty and John West Kemper

C. Walder Parke Family Foundation

Mr. and Mrs. Charles P. Bolton

Published in cooperation with the Western Reserve Historical Society

LIBRARY OF CONGRESS CATALOGING-IN-PUBLICATION DATA
Dee, Christine, 1972–
 Feel the bonds that draw : images of the Civil War at the Western Reserve Historical Society / Christine Dee.
 p. cm. — (Cleveland illustrated history series)
 "Published in cooperation with the Western Reserve Historical Society."
 Includes bibliographical references and index.
 ISBN 978-1-60635-091-1 (hardcover : alk. paper) ∞
1. United States—History—Civil War, 1861–1865—Pictorial works. 2. United States—History—Civil War, 1861–1865—Photography. 3. Photography—United States—History—19th century. 4. Western Reserve Historical Society—Photograph collections. 5. United States—History—Civil War, 1861–1865. I. Western Reserve Historical Society. II. Title.
 E468.7.D44 2011
 973.7—dc22

 2011015160

British Library Cataloging-in-Publication data are available.

15 14 13 12 11 5 4 3 2 1

For my father, Ronald Doyle, with love.

"Feel the Bonds That Draw": Images of the Civil War at the Western Reserve Historical Society
Christine Dee

CONTENTS

ACKNOWLEDGMENTS

This project would not have been possible without the vision and support of the Kent State University Press and the Western Reserve Historical Society. While I am unable to claim credit for the idea for a book highlighting the rich collections of Civil War images at the Western Reserve Historical Society, I am certainly grateful for the opportunity to delve into the past through the images in the collection's holdings and to bring both familiar and lesser-known images before the public through the Kent State University Press. I would like to thank Will Underwood, the director of the Press, and Joyce Harrison, the acquiring editor, for their support for the project. Managing editor Mary Young deserves special recognition for her patience and sound advice throughout this process. Michelle Luscre, the student intern at the Press, did an excellent job locating images and securing copies from the Western Reserve. In Cleveland, Ann Sindelar, the reference supervisor at the Western Reserve, and John Grabowski, the historian and vice president of the collections, could not have been more helpful and made trips to the archives both rewarding and enjoyable. I also owe thanks to Benjamin Smith, my research assistant at Fitchburg State University, who compiled references and provided unique insight on the project.

I would like to acknowledge the work that occurs on my own home front, where my husband, Brad Dee, provides consistent support, understanding, and good humor that enhances everything I do. My sons, Jeb and Bill, are always willing to provide distractions, needed or not, and are always willing to disturb microfilm, rifle through books, and share their own creative insights. I could not love them more. I would also like to thank my extended family, including Diane Doyle, Colleen Ergin, and Janet Gacek, for their encouragement. Finally, I want to thank my father, Ronald Doyle. From as early as I can remember, he showed me the places that have made American history. His love of travel and natural curiosity have inspired my work as a historian. He was the first person who helped me see the past and for that I am eternally grateful.

Nothing can lift the heart of man
 Like manhood in a fellow-man.
The thought of heaven's great King afar
 But humbles us—too weak to scan;
But manly greatness men can span,
 And feel the bonds that draw.

—from "On the Photograph of a Corps Commander,"
Battle-Pieces and Aspects of the War, by Herman Melville

INTRODUCTION

In Herman Melville's 1866 collection of poetry, *Battle-Pieces and Aspects of the War*, between poems on the carnage at the Wilderness and the destruction of Charleston are verses inspired by the photograph of a soldier. In his poem "On the Photograph of a Corps Commander," Melville reflected on the image of a Union officer. The identity of the officer is in question. Some believe Melville was inspired by Ulysses S. Grant, Winfield Scott Hancock, or others. Whether the inspiration was Grant, Hancock, or an archetype of a Union officer, Melville saw poetry in the photographic image. "Nothing can lift the heart of man / Like manhood in a fellow-man," he wrote. His verses acknowledge that the divine seemed distant, but the wartime photograph made it possible to know the greatness of man and, as Melville suggested, to "feel the bonds that draw." For the poet, and for millions of Americans, the images of the Civil War—photographs, engravings, and cartes de visite—created multiple bonds. Viewing photographic images brought each individual closer to war, drawing in a person so he or she could assess the documentary evidence. The images revealed heroic volunteers, mobilization of regiments, preparations for battle, and the battle's grim aftermath, including scenes of maimed bodies and lifeless corpses. More than simply evidence of people and events, however, the Civil War photographs brought Americans together in a collective experience whereby the public shared in the emotive power of the photographs and sought ways to make cohesion and order out of the thousands of images that swirled through the marketplace. The process of viewing, collecting, preserving, and sharing Civil War photographs also helped Americans remember, commemorate, and reinterpret the war for a century and a half.

When the Civil War began in 1861, photography in America was a bit more than two decades old. While the French inventor Joseph-Nicéphore Niépce is credited with capturing the first fixed image on a metal plate in 1827, it was his countryman Louis-Jacques-Mandé Daguerre who mastered the chemical process that allowed images to be fixed when light reacted with silver compounds on a metal plate. When the plate was exposed to the fumes of mercury, a positive image emerged. That image was bathed in a fixative, and the product—a daguerreotype—was placed within a glass case to protect the delicate image. The American inventor of the telegraph, Samuel F. B. Morse, visited Daguerre in France in 1839 and learned his techniques. Upon his return to the United

States, Morse, along with others, promoted the art of the daguerreotype. An exhibit in New York City that year captured the interest of the public and inspired people to take up the technology. Among these was Edward Anthony, who would move from engineering into daguerreotype and then from wartime photography into the photography supply business. The daguerreotype process spread quickly across America, especially when exposure times were reduced dramatically in 1843 with improved chemical procedures. Galleries sprang up in New York; Boston; Washington, D.C.; Charleston, South Carolina; New Orleans; and dozens of smaller cities throughout the nation. Thousands of Americans, including women and African Americans, embraced the emergent technology and honed their craft.[1]

The daguerreotype spawned a market for portraits across the country, but the technology was limited. Each image was unique, made without a negative, and provided no other means of reproducing the image. To reproduce the image, daguerrean artists relied on engravers and lithographers to transfer their unique images into affordable reproductions for a mass audience. Renderings of politicians and political scenes proved especially popular. It was Englishman William Henry Fox Talbot who pioneered a different process that would transform the history of photography. Talbot produced a negative image on light-sensitive paper, then transferred it to a second piece of paper in the form of a positive image. The resulting calotype rendered an image in brown tones but without the sharp details of the daguerreotype. In 1851, Fox's countryman Frederick Scott Archer improved on the technology of the negative. Archer invented the process that used a glass plate, covered with a thick, light-sensitive liquid, to replicate an image. The wet-plate, or collodion, process produced a glass negative that surpassed the calotype in clarity and detail. It also made it possible to print multiple images from the negative, which reduced the price of photographs. The introduction of reactive albumen-coated paper in 1850 improved the image quality. At the same time, the glass negative gave rise to more affordable alternatives to the daguerreotype—the ambrotype, the tintype, and the carte de visite. Photographs were reproduced as engravings in illustrated periodicals such as *Harper's Weekly* and *Frank Leslie's Illustrated Newspaper,* which reached hundreds of thousands of readers in urban and rural America. Technological innovations decreased exposure times, improved image quality, facilitated mass production, and made photographic images accessible to a larger number of Americans in the nineteenth century.

The increased demand for images reflected an American culture that was enchanted with technological innovations and that was able to transmit information from distant places. In response, photographers traveled throughout the world, capturing images that were reproduced for the American market.[2] Americans wanted to view famous locations around the world. While the wealthy could travel, those of more modest means could view the array of photographic images depicting the natural and man-made features of landscapes in the Middle East, Europe, and the American West.[3] The stereoscope

brought these images into bold relief for viewers. Two images of the same object, taken by adjacent lenses, were brought together through a tabletop or handheld apparatus to produce a single, three-dimensional image. Photographers and photographic printers churned out thousands of stereoscopic views and sold them as sets across the United States. The stereoscopic views offered Americans entertainment and educational opportunities, allowing viewers to bring public scenes, events, and the natural world into the private, domestic world of the home. Photography became a mode of entertainment, a means to education, and a marker of status and success to the emerging middle class. A family in Springfield, Illinois, was likely among this group of photographic consumers who invested in a stereoscope; it would seem that the Lincolns, like millions of others across the country, had become captivated by the power of the photographic image. Evidence indicates that Lincoln himself understood the political value of having his portrait taken. In the presidential campaign of 1860, Lincoln's photographic image played a crucial role in introducing him to the electorate and consolidating support for the Illinois Republican. The carefully composed portrait of Lincoln became the most recognized image of the future president during the campaign, and it was reprinted in *Frank Leslie's Illustrated Newspaper* and in *Harper's Weekly* and printed as a lithograph by Currier and Ives. When a supporter requested that Lincoln send him his photograph, Lincoln responded that he did not have any, but that he had visited "one of the places where they get up such things" and supposed they captured his "shaddow" [*sic*].[4]

"They" referred to Mathew Brady and his assistants in Brady's studio on Broadway in New York City. Of all the entrepreneurs who capitalized on the photographic technology, none was more well-known than Mathew Brady. Brady had learned the techniques of the daguerreotype when the practice was in its infancy. By 1844 he had opened a gallery, the Brady Daguerrean Miniature Gallery, in New York City. The gallery was the site of both photographic portrait production as well as a viewing gallery that was open for visitors. Specializing in portraits of famous people, Brady created a public reputation as the preeminent photographer of his day. He traveled to London in 1851 and won awards for his daguerreotypes at the Crystal Palace Exhibition. He also aggressively expanded his business, opening a second New York studio. During the 1850s, Brady faced competition from photographers who produced images that were more affordable to the public, yet Brady emphasized quality and artistry as his hallmarks and advertised himself accordingly. He also adopted the wet-plate/collodion process. As his business expanded, Brady—who suffered from vision loss—hired numerous assistants, including Alexander Gardner, a native of Scotland, who was an expert in making large, imperial prints as well as the popular carte de visite images.

The portrait business suffered from the effects of the economic depression of 1857, and photographers across the country complained of slow business. Despite this, Brady expanded his business—and overextended his credit—when

he opened a new gallery in Washington, D.C., in 1858. Gardner moved to Washington to manage the National Photographic Art Gallery, and Timothy O'Sullivan, one of the Brady photographers from New York, joined him in the new enterprise. Brady also expanded in New York, opening two additional studios in uptown Manhattan in 1860.[5]

By that point Brady had achieved name recognition and a professional reputation; Brady's work became the gold standard in photography. Behind the scenes, however, a regiment of photographers captured war images that bore the Brady name. Alexander Gardner and Timothy O'Sullivan went into the field and recorded images of the war, as would James F. Gibson and Brady himself. Brady copyrighted many of these images as part of two published series, "Scenes and Incidents of the War" and "Brady's Album Gallery." But the expenses of wartime photography exceeded the profits Brady hoped to achieve. He was indebted to New York photographic supplier and printer E. and H. T. Anthony and Company. When Alexander Gardner separated from Brady in 1862, he took negative copies of the images he had taken that comprised Brady's collections. Financial pressures caused Brady to sell a portion of his Washington business to Gibson in 1864. When the war concluded, Brady endeavored to sell his collection to the New-York Historical Society and to Congress, but neither would purchase his collection. To settle his account with Anthony and Company, he gave them copies of his war photos, which were published and marketed without profit for Brady. Brady declared bankruptcy in 1873, and two years later Congress purchased Brady's collection and he was able to pay his creditors. Brady would continue to operate his Washington studio but struggled with insolvency until his death in 1896 as a charity case in a New York hospital.[6]

Alexander Gardner would have greater financial success operating his studio in Washington, D.C., and traveling west as the chief photographer for the Union Pacific Railroad. His negatives, along with Brady's that were owned by Anthony and Company, were purchased by collectors Col. Arnold A. Rand and Gen. Albert Ordway. Rand and Ordway were Civil War veterans and active members of the Military Order of the Loyal Legion of the United States, a veterans' organization. Together, they amassed Civil War memorabilia, including the negatives that they sold to John C. Taylor. Taylor used the negatives to produce and sell prints in the 1880s and 1890s. The Taylor negatives would be sold again, to Edward B. Eaton, who used the negatives to publish a multivolume series on Civil War photographs in the early twentieth century. The Library of Congress purchased the original negatives in 1943. Before Rand and Ordway sold the negatives to Taylor, they produced two photographic albums from the original negatives, and one became part of the collection of Civil War photographs at the Western Reserve Historical Society.[7]

Selling the War: The Business of Photography

From the first days of war, photographers saw opportunity in crisis. By one account, more than three hundred photographers followed the Union army over the course of the war, in both the eastern and western theaters. They set up studios in camp and recorded images of individuals, camp life, and battle.[1] *Humphrey's Journal of the Daguerreotype and Photographic Arts* observed in September 1861 that the photography business had revived after a slump in the early months of war and that the affordable tintypes were very popular in both urban and rural areas as a way to capture images of soldiers departing for war.[2] The inexpensive tintypes would become the wartime portraiture for the masses, and millions were produced during the war.[3] Many photographers recognized that the war offered a chance to advance their profession and benefit their own careers. Reflecting on the success of Mathew Brady, one writer argued that a single photographer should not monopolize war photography and encouraged other photographers to go into the field to capture and print images of war. "Let other artists exhibit a little of Mr. Brady's enterprise, and furnish the public with more views," he suggested.[4]

Many photographers needed no such urging. George S. Cook was a traveling daguerrean artist in the 1840s who plied his trade from New Jersey to New Orleans and who finally settled in Charleston, South Carolina. When South Carolina voted to secede from the Union on December 20, 1860, Cook photographed the hall in Columbia and sold the image as a carte de visite. Cook traveled to Fort Moultrie and Fort Sumter to take photographs in early February, including a photograph of Union major Robert Anderson and his officers. Newspapers headquartered as far away as Philadelphia and New York took note of his photograph. Cook sold the photograph to *Harper's*

Weekly, and an engraving of the image was placed on the cover of the March 23, 1861, edition. Prints of Anderson's carte de visite sold by the thousands. Cook also profited by selling souvenir photographs to the Federal forces occupying the two Southern forts. After the Confederate bombardment of Fort Sumter and Major Anderson's surrender, Cook and other photographers captured images of the surrendered fort to market to Southerners. Among the most famous would be Cook's September 1863 image of an exploding shell during the Union bombardment. Images of Fort Sumter would make up the most available Confederate images of the war.[5]

A columnist in the *New Orleans Picayune* called for more images of military installations and preparations in May 1861. He believed that "posterity will have a fine chance of being delighted," which reflected the public clamoring for visual commemorations of the war.[6] Southern photographers such as J. D. Edwards responded by traveling to Fort Pickens, Alabama, to take photographs of Confederate camps along the Gulf of Mexico.[7] Far to the north, in Concord, New Hampshire, photographer Henry P. Moore also saw a business opportunity. Moore was a successful photographer who specialized in views of towns

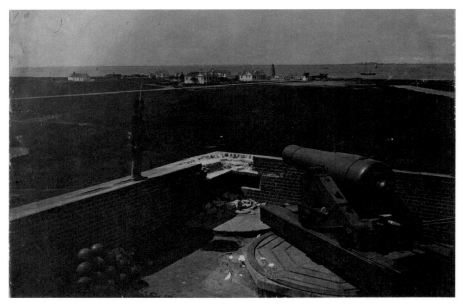

Fig. 1. Fort Pulaski looking toward Savannah, Georgia, northwest angle. Fort Pulaski was located on Cockspur Island, south of Savannah, Georgia, at the mouth of the Savannah River. Named for Count Casimir Pulaski, the Polish-born Revolutionary War hero who died in a failed attempt to regain Savannah from the British in 1779, the fort was begun in 1829 when Lieutenant Robert E. Lee chose the site and began engineering work. After 1831, Lt. Joseph K. Mansfield oversaw construction, which was completed in 1847. The fort, begun as part of a Federal project of coastal defenses, was unfortified in the winter of 1860–61. Georgia governor Joseph P. Brown anticipated the state's secession from the Union and ordered the state militia to occupy the fort in December 1860. When Georgia seceded from the Union on January 19, 1861, Fort Pulaski was manned by Georgia militia, and cannon were installed on its parapets. In the spring of 1862, Union forces occupied Port Royal, South Carolina, and turned their attention to the fort. On April 10, 1862, after months of Union preparation and reinforcement of surrounding coastal islands, the Union army opened fire on the fort with rifled cannon. After more than thirty hours of bombardment, Confederate forces surrendered the fort.

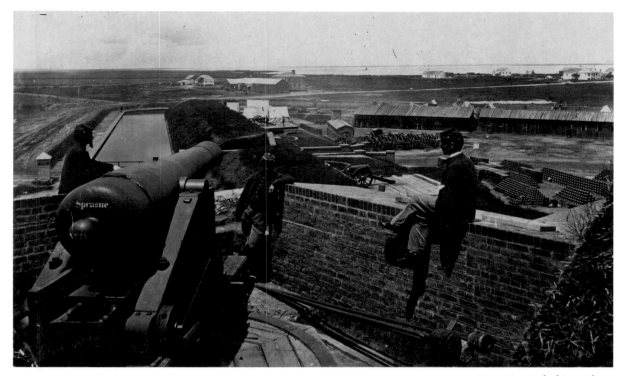

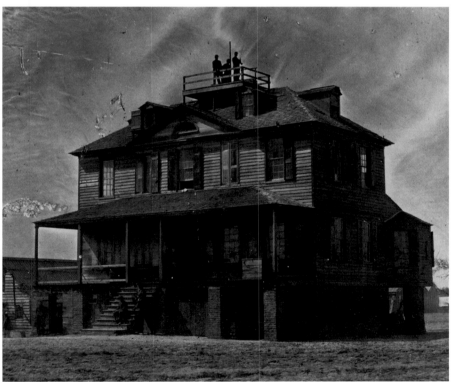

Fig. 2. Fort Pulaski, south-west angle. The capture of Fort Pulaski strengthened the Union blockade of the Confederate coast. When Union soldiers garrisoned the fort, they repaired the damage caused by the siege. They also occupied themselves by posing for photographers, receiving visitors from home, and playing games that included baseball within the fort's walls. Fort Pulaski remained under Federal control for the duration of the war and was used as a prison for Confederate officers and government officials.

Fig. 3. Signal station at Hilton Head, South Carolina, at William Pope's Coggins Point Plantation. William Pope, a wealthy planter and South Carolina state legislator, owned more than two hundred slaves in 1860 and hundreds of acres of land on Hilton Head. The large, elevated frame home was a prominent point on the flat coastal island and was proximate to Fort Walker, erected by Confederate forces to protect Port Royal Bay. The earthen works proved ineffective when on November 7, 1861, Union naval forces under Flag Officer Samuel Du Pont landed warships and troop transports carrying more than twelve thousand soldiers. In four hours, the Union forced Confederate forces to abandon the fortifications. White residents of the island fled. When Union troops came ashore, they buried their dead near Pope's house, and it was used as headquarters for the Department of the South.

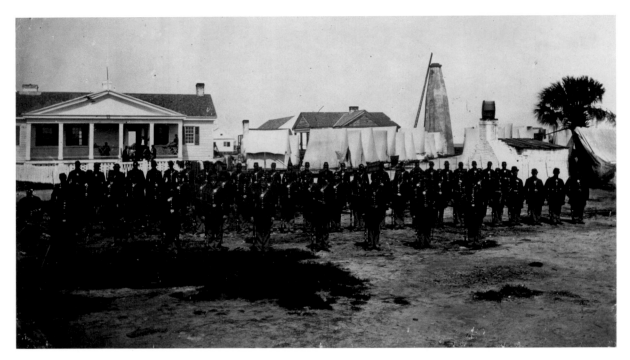

Fig. 4. Cockspur Island, camp of the 1st New York Engineers, Company F. The 1st New York Engineers were mustered into service in September 1861, at New York City. The engineers became the Tenth Corps Engineers, Department of the South, and served in the coastal campaigns along South Carolina, Georgia, and Florida. The corps accompanied Du Pont when he captured Hilton Head and built the fortifications from which the Union launched the assault on Fort Pulaski. The corps was detached from the Department of the South and joined the Army of the James in 1864 for the campaign in Virginia.

in New England. Indeed, his work was held in such esteem by his neighbors that his image of Concord was included in a time capsule at the local Universalist church.[8] In February 1862, Moore left his studio in Concord and traveled south to Hilton Head, South Carolina, where the 3d New Hampshire Regiment was encamped. Moore set up shop in an environment that could not have been more different from his Concord studio and documented scenes that would bring images of soldiers' camp life to their families at home. Other photographers, such as Timothy O'Sullivan who worked for Mathew Brady, were drawn in a similar way to the coastal islands in 1861–62, recording images of Union fortifications and encampments in an early theater of Union advancement. Together, these photographs incorporate traditional forms of portraiture with romantic views of landscapes and military art, with its emphasis on heroic service. Moore's photographs documenting the experiences of African Americans, however, move toward realism and detail aspects of former slaves' lives on the coastal Sea Islands as they moved from slavery to freedom. These images were Moore's most lasting photographic legacy.[9]

When Henry Moore arrived on the Sea Islands of South Carolina and Georgia in late February 1862, he focused on documenting the military fortifications and soldiers, which he believed would draw the greatest interest among buyers. In the process of capturing views of Fort Pulaski, which guarded the river leading to Savannah; the Union Signal Station on Hilton Head; and the camp of the 1st New York Engineers on Cockspur Island, Moore documented a flat, hot, and tropical landscape that would stand in stark contrast to the rolling, wooded landscapes and rocky coastal vistas familiar to the families of the New Hampshire, New York, and Connecticut regiments he photographed (figs. 1, 2, 3, 4). Moore took photographs of soldiers in traditional poses and

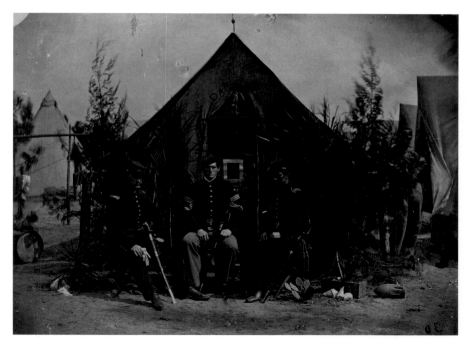

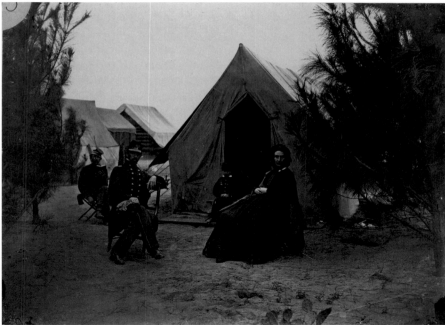

Fig. 5. 6th Connecticut Volunteers. Benjamin F. Prouty, Gustavus S. Dana, and Daniel Klein posed for Henry P. Moore in the spring of 1862. Lieutenant Dana, a Hartford native, is seated in the center. He enlisted in the 1st Connecticut Volunteer Infantry in April 1861. When his three-month enlistment ended, he enlisted in the 6th Connecticut for three years. A year after this picture was taken, he was promoted to captain of the United States Signal Corps. He resigned his commission in 1864 and moved to Springfield, Illinois, the following year. He remained active in veterans' organizations and, like many former soldiers, collected photographs and cartes de visite that commemorated his service.

Fig. 6. Surgeon Albert Moulton, 3d New Hampshire Volunteers; his wife, Anna; and his son, Arthur.

groupings as he would have in his studio in Concord, replete with props, but in his outdoor studio on Hilton Head Island, he posed soldiers with cacti, palmetto fronds, and sea shells, as well as their swords, books, clocks, and tinware (fig. 5). The result is a collage of natural, military, and domestic artifacts that mark the novel circumstances in which Union volunteers found themselves as they occupied the coastal islands in early 1862.

In the spring of 1862, surgeon Albert Moulton of the 3d New Hampshire Volunteers enjoyed a visit from his wife, Anna, and their only child, six-year-old Arthur. The photograph testifies to the complicated relationship between

Fig. 7. John E. Seabrook's house, Oak Island plantation, Edisto Island, South Carolina, with cotton drying on the lawn. When the Union army occupied Edisto Island, they confiscated Confederate cotton. The long-staple Edisto Island cotton drying on the lawn was salvaged from the Union ship *Empire,* which was wrecked on a sandbar along the coast on March 26, 1862. When William Seabrook died in 1860, an inventory of his estate listed 119 slaves residing at the plantation, valued at more than $61,000. Seabrook's total wealth was appraised at $187, 423, which included land, boats, furniture, livestock, and a library worth more than $3,000.

Fig. 8. Union soldiers at John E. Seabrook's house, Oak Island plantation, Edisto Island, South Carolina. The house served as Union headquarters on the island, and soldiers camped throughout the plantation.

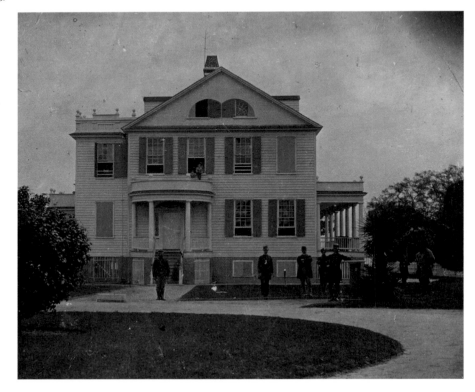

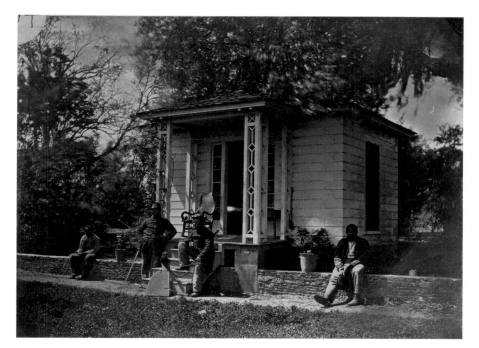

Fig. 9. Union soldier and African Americans outside Seabrook's library, Oak Island plantation, Edisto Island, South Carolina. The three African Americans pictured were part of the community of Oak Island slaves who forged new lives as slavery eroded on the Sea Islands in 1862.

military service and domestic life (fig. 6). Women and children in camp could be seen as softening the harsh realities of war, bringing the virtues of the family and femininity to the masculine world of the military camp, and binding regiments closely to their communities. They could also, however, be seen as a mark of status and differentiation between rank-and-file soldiers and officers. Dr. Moulton received more pay than any member of the regiment, except the colonel and the lieutenant colonel. Just months after this photograph, the physician was discharged for disability, and he returned home to Concord, New Hampshire. In later years, Moore's photographs would be lauded as the only remaining renderings of soldiers who never returned from war, but at the time they served to illustrate the camaraderie of camp life and to underscore that soldiers in the field continued to value the domesticity that was so central to nineteenth-century Americans' understanding of civilized society.[10]

The plantation house was built in 1828 by William Seabrook, a wealthy Sea Island cotton planter. When he died in 1860, the house passed to his son, John Seabrook, who lived in the opulent estate called Oak Island. This cotton-producing plantation was home to not only the Seabrook family but also multiple overseers, carpenters, small farmers, and more than one hundred slaves. Among these were Will and Jack, both of whom worked in the yard; John, a blacksmith; Renty, a carpenter; Noah, the coachman; Joan, the cook; and Betsey, who suffered from mental illness. These individuals, with the rest of the slaves, were the foundation of the Seabrook family wealth, which is evident in the photographs (figs. 7, 8). When Henry Moore took photographs at Oak Island, he included African Americans, whose status was ambiguous in the spring of 1862, with their owners in exile and Union forces occupying the island (fig. 9).

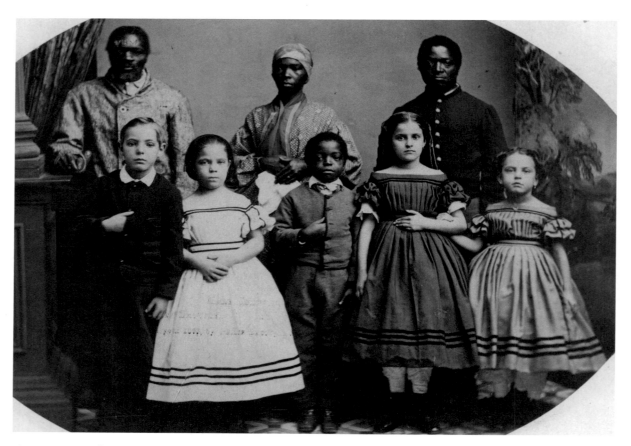

Fig. 10. Portrait of emancipated slaves. Back row (left to right): Wilson Chinn, Mary Johnson, and Robert Whitehead. Front row (left to right): Chas Taylor, Augusta Broujey, Isaac White, Rebecca Huger, and Rosina Downs. The original caption with this photograph read, "Portrait of Emancipated Slaves Brought from Louisiana by Colonel General H. Banks. The Children Are from the Schools established by order of Maj. Gen. Banks. Photographed by M. H. Kimball, printed by George H. Banks, 1863."

Images of formerly enslaved African Americans played an important role in shaping public opinion in the North in support of emancipation both as a military strategy and, for growing numbers of Northerners, as a moral imperative. Figure 10 was designed to convey the horrors of slavery to the Northern public, including the branding of Wilson Chinn's forehead with his owner's initials and the interracial children who were enslaved as a result of the slave status of their mothers. The image conveys as well the dignity of African Americans and their willingness to fight for the Union. This photograph was taken by M. H. Kimball, a photographer with a studio on Broadway in New York City, as part of a series of images of former slaves from Louisiana. The image was reproduced in *Harper's Weekly* in the January 30, 1864, issue with the caption "Emancipated Slaves—White and Colored." It was accompanied by an article that described the lineage and enslaved experiences of each, as well as their intelligence and the education they received through the Freedmen's Bureau schools. The images were offered for sale to promote the National Freedmen's Relief Association.

Because slaves were considered property, ones who escaped to or were brought within Union lines were deemed "contraband" and were held in contraband camps. Images of an African American man in a contraband camp (fig. 11) and a visibly pregnant African American woman in front of a slave

pen (fig. 12) appealed to Northerners' tendency to associate the war with the end of slavery by underscoring the humanity and dignity of individual African Americans—values denied by the institution of slavery.

Throughout the war, photographs from the front reached Northern audiences, many in the form of stereoscopic views, which allowed civilians to virtually travel along with the Union army's movements in places such as Yorktown, Harrison's Landing, Seven Pines, Culpeper Court House, and Cedar Mountain (figs. 13, 14, 15). Photographer James Gibson took images of the field hospitals after the Battle of Seven Pines, or Fair Oaks, in June 1862, including a frame house with a fresh grave carefully outlined in the front yard (fig. 16) and

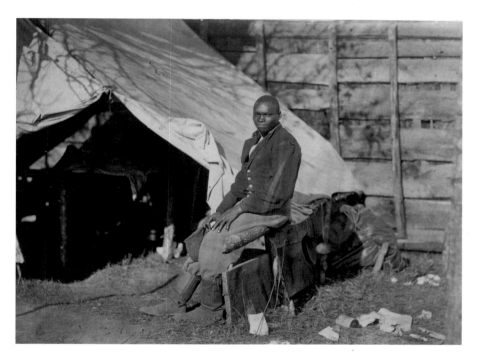

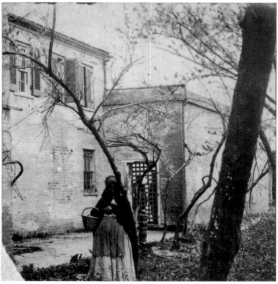

Fig. 11. African American man in contraband camp, Culpeper, Virginia. The man in this photograph was also included in a photograph that depicted two African American men in a camp established for refugees from slavery who passed within Union lines.

Fig. 12. African American woman in front of a slave pen, Alexandria, Virginia. This photograph of an African American woman in front of a building that had been used as a holding place for slaves as they awaited sale was reproduced as a stereoscope card.

Fig. 13. Army of the Potomac, Camp Winfield Scott, near Yorktown, Virginia, May 1862.

Fig. 14. Camp in the woods, near Culpeper, Virginia. Culpeper Court House was located between Washington, D.C., and Richmond, Virginia, and was an important railroad depot. The town was occupied by Union and Confederate troops at different stages of the war, serving as a major route of invasion as well as headquarters for both Robert E. Lee and Ulysses S. Grant. Union troops occupied the area in the summer of 1862, but Confederate victory at the Battle of Cedar Mountain in August placed the town within Confederate lines. The Union army returned to Culpeper in September 1863. When the army advanced toward Richmond in May 1864 in the Overland campaign, Culpeper became a supply station in the Union rear.

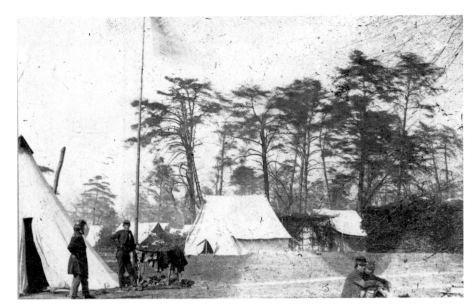

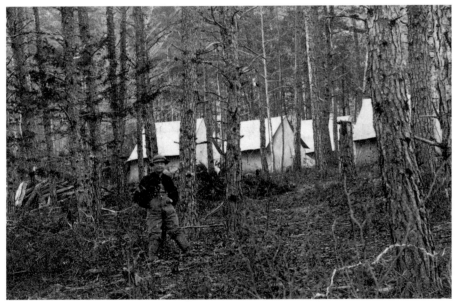

Lafayette's headquarters being used as a hospital (fig. 17). Timothy O'Sullivan chronicled the presence of the photographers in his picture of James Gibson and captioned it, "Our Special Artist at Manassas, July 4, 1862" (fig. 18). He also captured the Union artillery crossing the Rappahannock River on August 9, 1862, the day of the Battle of Cedar Mountain, which provided a sense of immediacy to viewers who clamored for views of the battlefield taken soon after the fighting ceased (figs. 19, 20, 21).

In the fall of 1862, the marketing of Civil War photographs came of age in an exhibit of images that influenced public opinion and altered war photographers' focus. On September 17, Union and Confederate forces fought in Maryland, at Antietam Creek (this battle was also referred to as Sharpsburg by the Confederate armies). Two days after the bloodiest day in American history,

Gardner and Gibson arrived at the battlefield and began taking what would comprise a corpus of more than seventy images. The images were the first taken of unburied dead during the war, and their exhibition by Mathew Brady in New York City in October elicited intense feelings among the public.

For some observers, the photographers served as a contrast to those who went through their daily lives seemingly untouched by the casualties of war and the sacrifice of human life. Oliver Wendell Holmes was a physician, author, poet, and the inventor of a handheld version of a stereoscope. His son, Oliver Wendell Holmes Jr., who would later become a U.S. Supreme Court associate justice, enlisted in the Union army and was wounded at Antietam, which prompted his father to search the battlefield for his son. In an essay

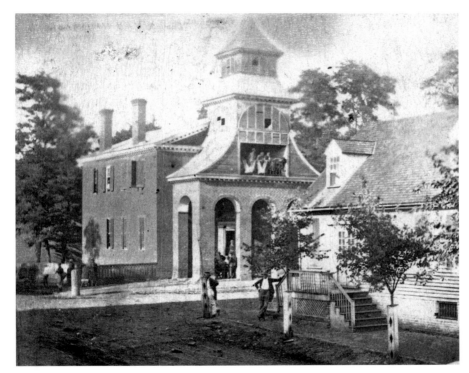

Fig. 15. Culpeper Court House. This picture is reputed to show captured Confederates who were housed in the court house when the Union army occupied the town.

Fig. 16. Seven Pines Battlefield, old frame house used as a hospital.

Fig. 17. Lafayette's headquarters, American Revolution.

published in the *Atlantic Monthly* in the summer of 1863, the author, inventor, and father wrote about the impact of photography and Brady's exhibit: "Let him who wishes to know what war is look at this series of illustrations. These wrecks of manhood thrown together in careless heaps or ranged in ghastly rows for burial were alive but yesterday. How dear to their little circles far away most of them!—how little cared for here by the tired party whose office it is to consign them to the earth! An officer may here and there be recognized; but for the rest—if enemies, they will be counted, and that is all." Holmes acknowledged the sentiment that wanted to lock away such images. He wrote, "It was so nearly like visiting the battlefield to look over these views, that all the

Fig. 18. Photographer James Gibson at Manassas, July 4, 1862. This photograph shows both the photographer and the wagon that carried his studio in the field.

Fig. 19. Federal Battery fording the Rappahannock.

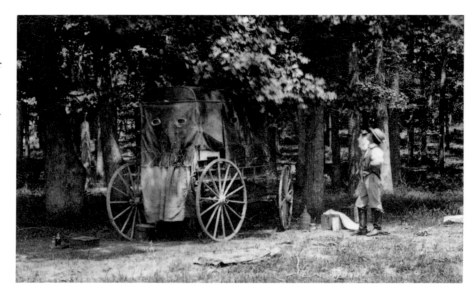

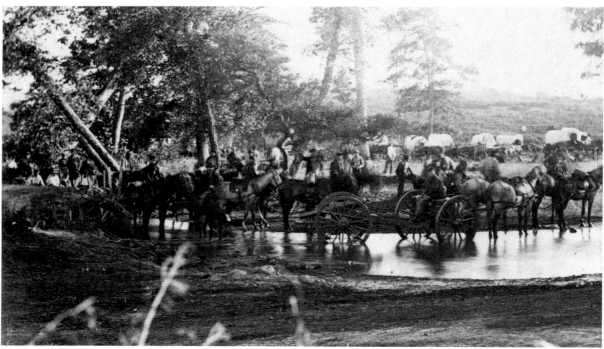

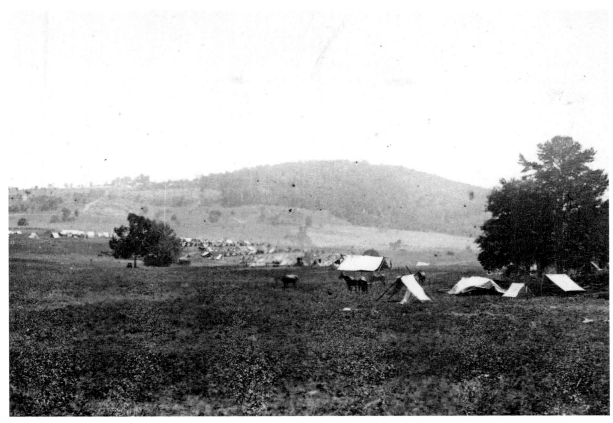

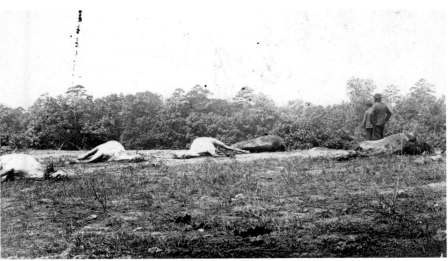

Figs. 20 and 21. Cedar Mountain Battlefield. The dead horses on the field portrayed a different perspective of the battle's cost. During the war, horses were essential to both armies' ability to maneuver, carrying supplies and armaments. Procuring horses and securing resources to feed and care for the animals were a challenge for quartermasters during the war.

emotions excited by the actual sight of the stained and sordid scene, strewed with rags and wrecks, came back to us, and we buried them in the recesses of our cabinet as we would have buried the mutilated remains of the dead they too vividly represented." Holmes believed, however, that the battlefield pictures should be captured and viewed by the public because they provided "some conception of what a repulsive, brutal, sickening, hideous thing it is, this dashing together of two frantic mobs to which we give the name of armies." The photographs caused him to reflect that war "always implies that

something worse has gone on before. Where is the American, worthy of his privileges, who does not now recognize the fact . . . that the disease of our nation was organic, . . . calling for the knife, and not for washes and anondynes?"[11] For Holmes, the photographs conveyed in detail the cost of war, and he testified to the accuracy of the images in the exhibit. The evidence of the battle's cost, specifically in lives lost, served to remind Americans that the source of the war—slavery—could only be eradicated by surgical removal or

Fig. 22. Antietam Battlefield, William Roulette's house. The farmhouse sustained damage on the first day of the battle. Union soldiers passed through the farm as they advanced to the Sunken Road, and the farmhouse was used as a field hospital. Roulette later claimed that hundreds of dead were buried on his land.

Fig. 23. Burial crew, Antietam Battlefield.

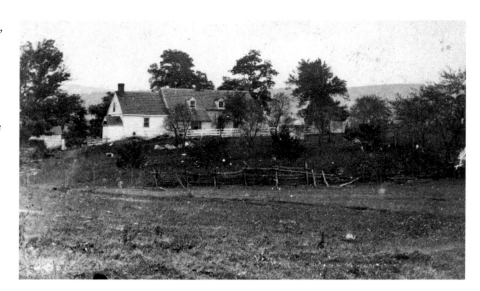

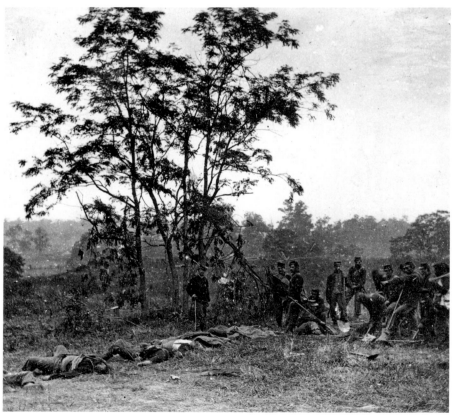

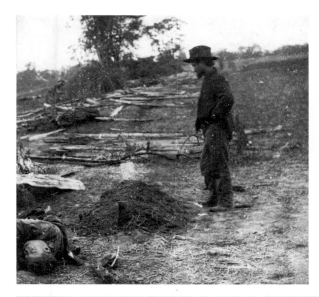

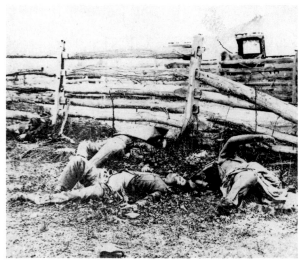

Fig. 24. Antietam Battlefield, burying the dead.

Fig. 25. Antietam Battlefield, bodies of the dead of a Louisiana regiment.

Fig. 26. Antietam Battlefield, graves of soldiers, Burnside Bridge.

the bloodletting that produced the shattered landscapes and lifeless bodies in the exhibit (figs. 22, 23, 24, 25, 26).

When a writer for the *New York Times* viewed the Antietam photographs, he saw stark images of the cost of war and hoped the exhibit would shake Americans out of war weariness and complacency. There was among people at home a disturbing inattentiveness regarding the war. "The living that throng Broadway care little perhaps for the Dead at Antietam, but we fancy they would jos-

tle less carefully down the great thoroughfare, saunter less at their ease, were a few dripping bodies, fresh from the field, laid along the pavement." People had become numb to casualty lists. "We see the list in the morning paper at breakfast, but dismiss its recollection with the coffee. There is a confused mass of names, but they are all strangers; we forget the horrible significance that dwells amid the jumble of type." The writer suggested that people would be more sensitized "if the newspaper carrier left the names on the battle-field and the bodies at our doors instead." In contrast, people who lived in Maryland, "with their door-yards strewed with the dead and dying, and their houses turned into hospitals for the wounded, know what battlefields are." The photographs, he wrote, were tantamount to laying the bodies in the dooryards and streets of communities far from the field of battle. They served to remind people "that there are truths dearer than life, wrongs and shames more to be dreaded than death." By linking the Antietam images with the "wrongs" that caused the war, the writer called for a renewed commitment to the war effort. At a time when Lincoln's issuance of the preliminary Emancipation Proclamation defined emancipation as part of the Union war effort, the photographs of the carnage at Antietam were important in the process by which the Northern public would affirm their commitment to a Union forever transformed. The photographs had the power to shape and mobilize public opinion, and the writer observed the effect in Brady's gallery. "Hushed, reverend groups" were "chained by the strange spell that dwells in the dead men's eyes," the observer wrote.[12] In this way, the spell, or bond, created between the spectator and the photograph was shared by multiple viewers, as well as by readers of the newspaper commentary, searing the images in the public's collective memory.

The Antietam exhibit, and wartime photography's turn away from heroic images of warfare to document the physical experience of it, served to remind and reinforce the Northern public's commitment to eradicate the nation's "wrongs and shames." On December 1, 1862, Lincoln presented his annual address to Congress in which he identified Americans' shared responsibility in preserving the Union and defined as well the truths that had emerged from the "fiery trial" of war. "In giving freedom to the slave we assure freedom to the free," he wrote. Within this context, the images of Antietam marked the departure from romanticized, limited, and antiseptic views of the war to the more graphic renderings of the war's cost. They both marked time and moved emotions just as Lincoln's policy and military strategy demanded that people recommit themselves to a war that grew increasingly more violent, expansive, and ultimately revolutionary.

CHAPTER
TWO

Ordering War

From the war's beginning, photographs played an important role in shaping broad currents of public opinion as well as individuals' responses to the war. Photographs and the lithographic prints they inspired represent photographers' and artists' decisions about what facets of the war should be recorded and preserved. The photographs and lithographs also reflected what viewers wanted to see, capturing popular opinions about war, mobilization, military camps, and government installations.[1] When local photographers set up their equipment to record the departure of a local regiment, as was done in Chillicothe, Ohio, or when Edward Sachse drew a scene of a Union encampment on stone to print a color lithograph in his Baltimore studio, they were recording the process by which volunteers left their communities and joined together in military encampments. The photographers and printers did this within a particular framework, or way of understanding the war, that swirled around them. Soldiers and people at home shared in the effort. When the 8th New York Regiment encamped at Fort Morgan in May 1861, a soldier wrote home, "You will soon have a photograph of our camp, an operator being now at work on the opposite hill." The soldier described each feature of the camp and person in great detail and predicted the image would soon be for sale in New York. He only regretted that the photographer's lens did not capture their kitchen, which was "skillfully arranged."[2]

Photographers and engravers alike framed their images around the entirety of a regiment, or an encampment, placing it within the context of the landscape by using an elevated and distant vantage point. This approach to recording camp scenes was a familiar one to nineteenth-century viewers. Beginning in the 1820s, artists and printers produced thousands of views of

towns and cities. These views were a commercial success, decorating homes across the nation. They promoted settlement and growth while supporting Americans' ideological commitment to territorial expansion and nationalism. The views, with their expansive, aerial perspective; linear order; and ability to convey spatial, economic, and social information, ameliorated some of the harsher, discordant aspects of industrialization and the market economy. Absent from these views of towns and cities were images of the poverty, overcrowding, disorder, and environmental costs of settlement. The images of military camps and hospitals served a similar function. Images of these places, often taken from an elevated perspective, displayed a linear sense of order, emphasizing the positive value of the enormous and monumental process of mobilizing vast numbers of individuals in a single place, presumably for a single purpose. The photographs and lithographs privileged images that conveyed order and discipline over images of the local and parochial. In this way, these images supported enlistment and the government's calls for volunteers. The camps and hospitals were presented as idealized places, similar in their presentation to the idealized communities they would leave. They were known and organized, devoid of elements that would threaten soldiers or civilians. The photographs and prints, viewed and purchased by soldiers and civilians, aided in Americans' understanding of the unprecedented events taking place in their lives.[3] Departure ceremonies, camps, and military hospitals were photographed, engraved, seen, and owned as part of the process by which Americans experienced the power of the federal government to muster men and matériel into federal service. Some people embraced the government's efforts, extolling the force of the Union. Others would come to accommodate and accept the centralized power of the federal government; still, others would stand in staunch opposition to it. The images of ceremonies, camps, and hospitals and the sense of authority and order they conveyed offered visual alternatives to narratives of confusion and the disordered images of battlefield carnage. In this sense, these images supported the Union war effort, undergirding the construction of Union nationalism.

The lithograph made of the 69th New York State Militia's departure from New York in April 1861 conveys a sense of military discipline and public support for the Union war effort in the war's early years (fig. 27). Sarony, Major, and Knapp's lithograph of the departure of what would become the core of the 69th New York Volunteers of the Irish Brigade, or the "Fighting 69th," was included as a foldout illustration in D. T. Valentine's *Manual of the Corporation of New-York* (1862). Presumably adding market appeal to the volume, the lithograph emphasized the well-drilled militia departing to the cheers and support of jubilant crowds. Consumers who examined the image, or cut it out of the manual to decorate their homes, were reminded why the volunteers fought: "No North, No South, No East, No West, One Whole Union," the parade banner declared in the foreground. That the regiment was the famed Irish 69th New York, which had gained a national reputation for its

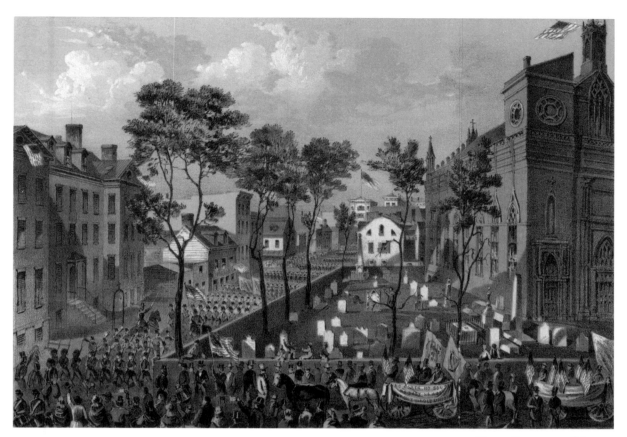

Fig. 27. Departure of the 69th Regiment, New York State Militia. Tuesday, April 23, 1861. Sarony, Major, and Knapp, New York City.

hard fighting in the First Battle of Bull Run and in the Peninsula campaign, increased the image's appeal to potential buyers in the Democratic stronghold of New York. Moreover, the artist's choice of emphasizing that the war was being fought for the limited goal of preserving the Union, not interfering with slavery, indicated Valentine's and his intended audience's understanding of the war in its early years.

The photograph of the 73d Ohio Volunteer Infantry's (OVI) departure from Ohio reveals the complexity of raising an army and cultivating public support as the war continued into the autumn of 1861 (fig. 28). On January 24, 1862, the 73d OVI departed from Chillicothe, concluding an enlistment process that had taken almost five months. The initial effort to raise the regiment began after the president's call for 300,000 men in September 1861. Recruiting began in October from Ross County and the region of south-central Ohio. Recruiting was slow. Companies were initially raised in the middle of November, but it took until the end of December to enlist sufficient men to fill the ten companies needed for a full regiment. An officer recalled, "At this period in the history of the war, recruiting was very difficult." He attributed the trickle of volunteers to a decline in the early war fervor of the spring of 1861 and believed that the defeat at the First Battle of Bull Run contributed as well. "The loyal nation paused, in grief, to weigh the value of the Union and count the cost of its salvation," he wrote.[4] The local photographer who turned his lens on the departing regiment may have captured public sentiment on the cold, winter

day when the men marched in orderly procession down the street, displaying the skills they had practiced for months in camp.

Thirty-year-old Thomas T. Sweeney was an engineer in Cleveland when the war began; he was a relatively new arrival to the state, having moved with his wife in the middle of the 1850s from New York. He rented a home in the Second Ward and lived among clerks, tailors, and other modest workers. By the time the war began, he had four children, all under the age of seven. Sweeney enlisted in the 7th Ohio in April 1861 as a first lieutenant. His military service would not last long. After seeing action at Cross Lanes in western Virginia, where the regiment was routed by Confederate forces and more than one hundred soldiers were captured and sent to a Confederate prison in New Orleans, Sweeney mustered out of his three-month service. He did not reenlist but remained in Cleveland. It is unknown when he began to practice photography, but he took up his camera in the summer of 1864 to document the return of the 7th Ohio Volunteer Infantry to northeastern Ohio (fig. 29). Soldiers in the 7th had fought in both the eastern and western fronts, with

Fig. 28. 73d Ohio Volunteer Infantry leaving Chillicothe, Ohio, 1862.

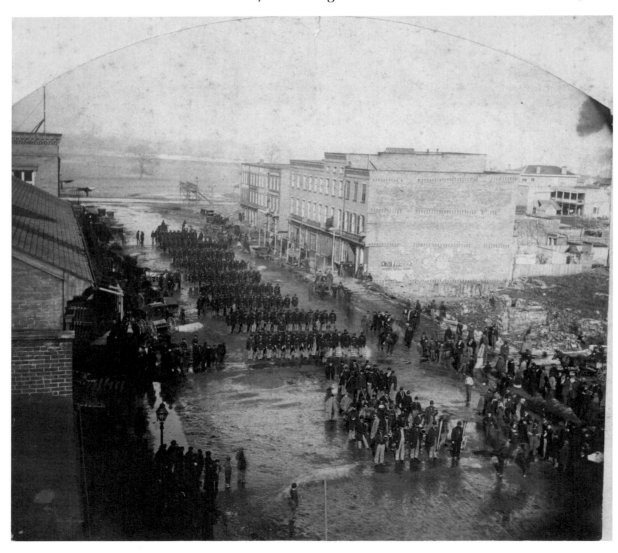

Fig. 29. 7th Ohio Volunteer
Infantry returning home,
1864.

the Army of the Potomac and the Army of the Cumberland. The regiment
participated in the Battles of Cedar Mountain, Second Manassas, Antietam,
Chancellorsville, and Gettysburg. The 7th went to New York City in response
to the draft riots and fought at Lookout Mountain, Missionary Ridge, Re-
saca, and New Hope Church. When the regiment's three-year commitment
expired, reenlisting soldiers and those who had remaining service joined the
5th Ohio Volunteer Infantry and fought in the Battle of Atlanta and partici-
pated in Sherman's March to the Sea. The veterans of the 7th who returned to
Ohio in the summer of 1864 posed in a rough, loosely formed line in a sparse
summer landscape. Sweeney's photograph reflected the hard service the 7th
had rendered since its departure in 1861. The regiment reached Cleveland on
June 24, 1864, but was greeted differently from when they departed. At least
one soldier would complain of the "meager reception" held for the regiment
in Cleveland on the Fourth of July.[5]

For Thomas Sweeney, the war provided photographic opportunities. He
became partners with another Cleveland photographer, and by the end of
the decade he was earning his living as a photographer, taking pictures of
subjects as varied as canal boats, public buildings, and artistic landscapes in
single and stereoscopic formats. Sweeney accumulated significant personal
property while his family expanded to include eight children. By 1880, he
operated a photography studio next to a saloon in the city's Second Ward,
aided by one of his sons and likely by some of his other children.

Photographs from the photographers who traveled with the Army of the
Potomac illustrate the results of recruiting efforts across the North. When
James Gibson was with McClellan's army during the Peninsula campaign in
the spring of 1862, he brought with him a stereoscopic camera and recorded
McClellan's vast command as they camped along the banks of the Pamun-
key River. For some of his pictures, Gibson climbed high into a tree to gain

an aerial view of the vast encampment at Cumberland Landing (figs. 30, 31, 32, 33). The site along the river was advantageous for landing supplies to support the Army of the Potomac, which numbered approximately 100,000 men. The sheer size of what appeared, at least from a distance, to be a well-ordered army in the photographs reflected the Union's efforts to mobilize

Figs. 30, 31, 32, 33. Cumberland Landing, Army of the Potomac, 1862. James Gibson's photographs document the Army of the Potomac's extensive encampment along the banks of the Pamunkey River, Virginia. His pictures parallel soldiers' impressions. As one Wisconsin soldier wrote, "Here, on a large plain, surrounded by an amphitheatre of bluffs, were collected about 70,000 of our troops, presenting from the high ground a most magnificent sight." Alfred Lewis Castleman, *The Army of the Potomac: Behind the Scenes; A Diary of Unwritten History* (Milwaukee: Strickland and Company, 1863), 143.

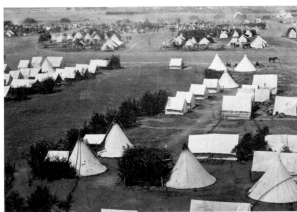

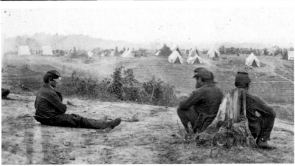

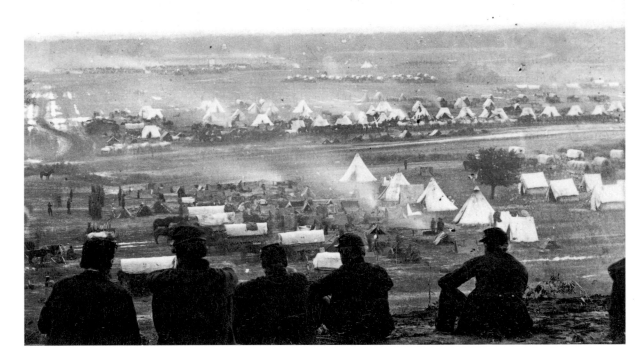

men as well as McClellan's attention to increasing the strength of the army under his command coupled with his propensity to drill in camp rather than move against the Confederates. The Union army moved up the Peninsula slowly, impeded by heavy rains and McClellan's mistaken conviction of the Confederates' superior numbers. Notwithstanding Lincoln's impatience with what he believed was McClellan's procrastination in attacking the Confederate defenses around Yorktown and Richmond, McClellan continued to amass troops and supplies at encampments like Cumberland Landing.

By the end of May, McClellan and his troops would reach within six miles of Richmond, but the success of Stonewall Jackson in the Shenandoah Valley diverted Union troops. Robert E. Lee's aggressive movements in May and June unnerved McClellan as well. After the Battle of Malvern Hill in July, in which Confederate casualties were double those of the Union forces, McClellan ordered his troops to retreat to Harrison's Landing rather than to counterattack, continuing his string of strategic losses in his failed Peninsula campaign. Alexander Gardner's photographs from the encampment in the late summer display little of the grand order captured by Gibson at the beginning of McClellan's campaign (figs. 34, 35).

Similarly, Alexander Gardner's photographs taken in February 1863 at Aquia Landing, along the Potomac, reveal a gritty, bustling, and somewhat chaotic supply base of an army that was struggling to meet the demands of a protracted war.

Pvt. Edwin B. Elliott may have painted figure 36 when his company was

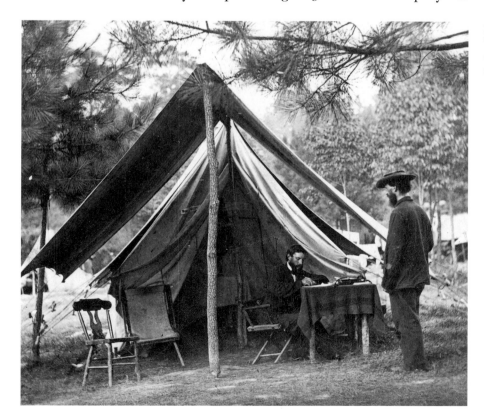

Fig. 34. Harrison's Landing, Virginia, headquarters of the Signal Corps, Army of the Potomac.

encamped at Aquia Landing after the Battle of Chancellorsville in May 1863. The area was an important Union supply base, with access to the Potomac River as well as the Richmond, Fredericksburg, and Potomac Railroad. When the Union abandoned the post and marched north toward Gettysburg weeks later, Confederates destroyed the base. The Union army rebuilt Aquia Landing

Fig. 35. Harrison's Landing, Virginia, Gen. Samuel Heintzelman and staff. The general, seated in the middle of the back row, was a graduate of West Point, veteran of the Creek and Mexican wars, and had received accolades for subduing Native Americans in California. In the First Battle of Bull Run, he was wounded in the arm and is reported to have ordered that the bullet be removed while he remained in the saddle. He had command of the Third Army Corps during the Peninsula campaign.

Fig. 36. Camp of the 109th Regiment, Pennsylvania Volunteers, Company A, Aquia Landing, Potomac River, Virginia. Pvt. Edwin B. Elliott had enlisted in the 109th Regiment in December 1861.

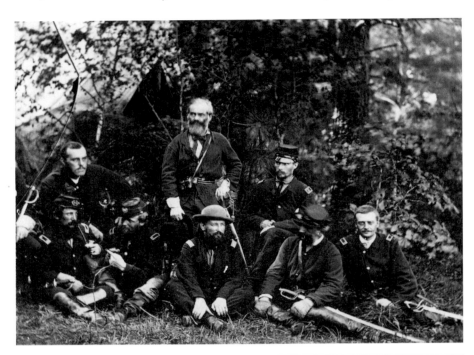

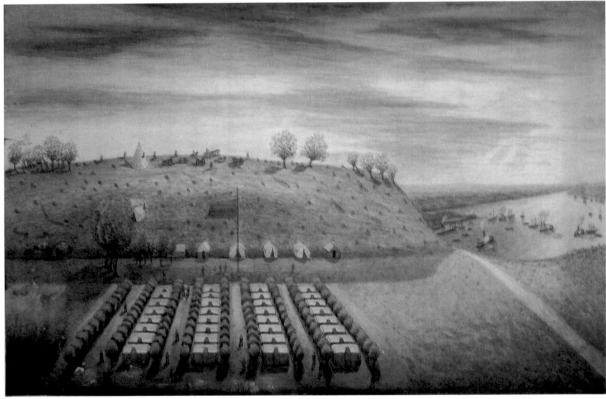

in 1864, but when they moved south, it was again destroyed by Confederates. The linear representation of the encampment, its easy place within the rural landscape alongside the river, and the sense of organization and tranquility it conveys reflect the imprint of earlier panoramic views of camps on the artist while presenting a window into one private's desire to render camp life as vibrant and organized, a place where the sun shown, ships carried supplies to troops, and the Union flag flew unchallenged. The camp view of the 31st Ohio Volunteers conveyed a place that offered shelter for the soldiers while nurturing their souls as they attended religious services. Idealized images of camp life persisted, even as photographers revealed it to be less organized, comfortable, or stable than the panoramic views presented (figs. 37, 38).

The Union army utilized Belle Plain, Virginia, as a supply base and an

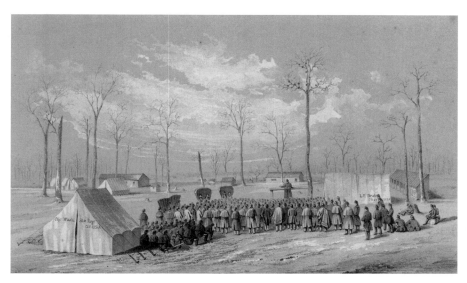

Fig. 37. Camp of the 31st Ohio Volunteers, Camp Dick Robinson, Kentucky, November 10, 1861. The Reverend Lemuel F. Drake, chaplain of the 31st and the 121st Ohio Regiments, was a thirty-eight-year-old Methodist Episcopal minister from Perry County, Ohio, when he joined military service. In camps in Kentucky and Tennessee, he ministered to soldiers, led services and revivals, and aided in distributing supplies to soldiers.

Fig. 38. Cumberland Gap, Tennessee. View from the South.

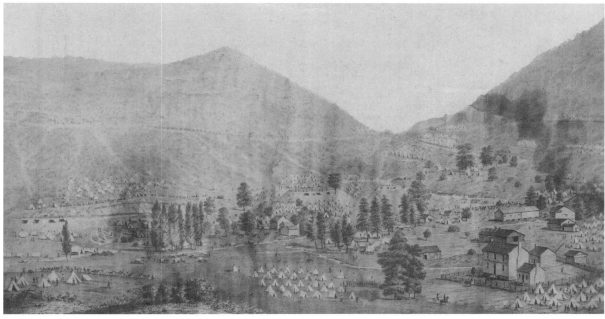

important transportation center where the sick and wounded waited for river transportation to Northern hospitals (fig. 39). In June 1864, *Harper's Weekly* wrote that "the appearance of the surrounding country is desolate in the extreme," although river transports, troops, supplies, and civilians moved through the area continuously.[6] Nurses and physicians traveled to the camps along the Potomac in the spring and summer of 1864 to care for the casualties from Grant's campaign. Confederate prisoners were transported to Belle Plain en route to prison camps in Northern states. It was here that James Gardner photographed Confederate prisoners taken in the Battles of the Wilderness and Spotsylvania in the geographic depression known as the "Punch Bowl"[7] (figs. 40, 41, 42).

The photographs of army camps, whether conveying the mobilization of manpower, the regimentation and orderly nature of military service, or the mobility and uncertainty of soldiers' lives, generally did not capture the disease and squalor that accompanied camp life (figs. 43, 44, 45, 46). From the

Fig. 39. Belle Plain, Virginia, Lower Wharf, 1864.

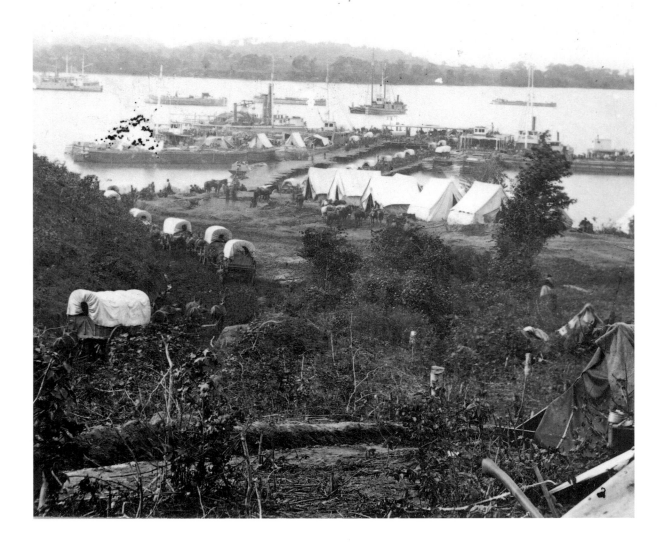

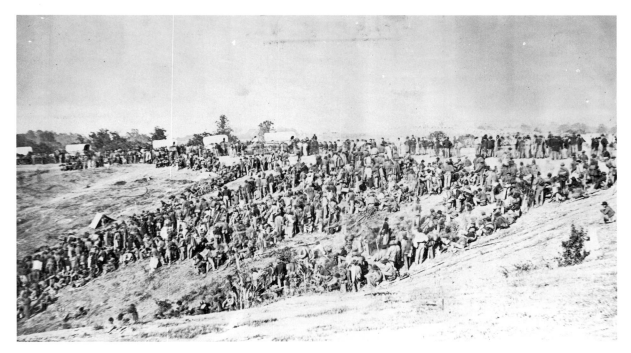

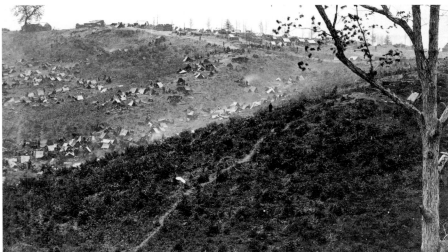

Figs. 40, 41, 42. Confederate prisoners at Belle Plain, Virginia.

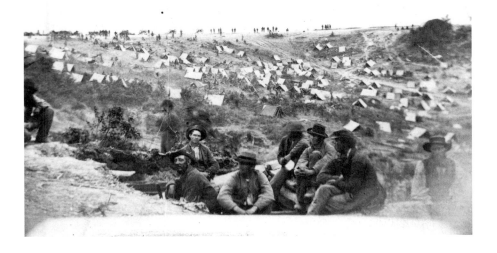

first months of mobilization, when a young population that was predominantly from rural areas and small towns was concentrated in encampments, epidemic diseases flourished due to inadequate sanitation. The army medical department proved unable to treat the number of sick soldiers in camp in the first year of the war. Regimental surgeons treated soldiers in camp and, in the wake of battles, at battlefield hospitals. A limited number of ambulance drivers transported the wounded to the hospitals. The casualties from the First Battle of Bull Run, however, highlighted the inefficiencies of prevailing procedures. Regimental surgeons were either overwhelmed by casualties in their regiments or saw little service. Ambulance drivers fled the field, leaving the wounded behind. Those who could walk returned to Washington, D.C., on foot; those who could not remained on the field and died or were captured.

Fig. 43. Headquarters of the Army of the Potomac, Brandy Station, Virginia, 1864.

Fig. 44. Quartermaster and ambulance camp, Sixth Corps, Brandy Station, Virginia, 1863.

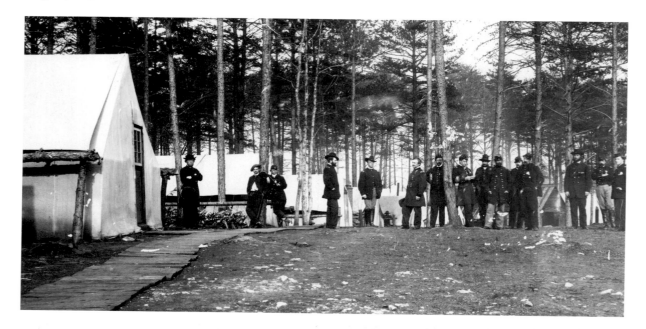

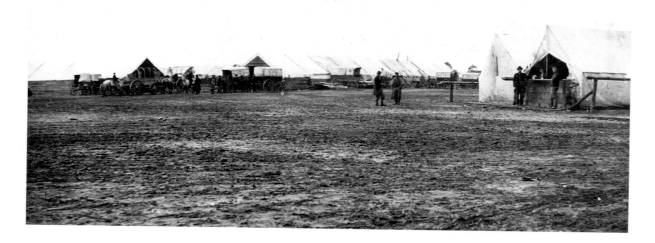

Fig. 45. Quarters of Provost Marshal Lieutenant Colonel Hall, Folly Island, South Carolina.

Fig. 46. Fort Burnham, Virginia, October 29, 1864.

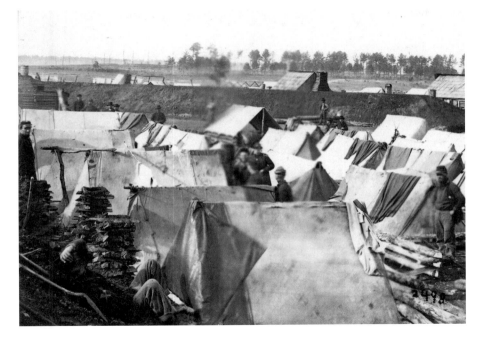

In the first year of the war, medical care was specific to regiments. Regimental surgeons and assistants were responsible for treating their own wounded. Insufficient and unreliable ambulances were inefficient in moving thousands of wounded soldiers to hospitals. The reorganization of the medical department in the Army of the Potomac addressed these shortcomings. In the Peninsula campaign, the medical department utilized the railroad as well as ambulances to remove the wounded, but ambulances were insufficient to move the wounded from the field to the depots (fig. 47). Wounded soldiers also faced delays as they waited for transport by rail or boat to the general hospitals.[8]

In January 1862, William A. Hammond was appointed surgeon general of the United States. Under his supervision, medical care became more efficient and effective. The government built general hospitals in a pavilion style with

single-story wards that emphasized sanitation as well as socialization of patients in distinct wards. Hammond was replaced by Joseph H. Barnes, who reported that medical care had improved, largely through centralization and strenuous efforts of inspection, which had added to the efficiency of hospitals and medical service. Views of military hospitals reflected the centralization of medical care after 1862. Photographs show well-organized institutions, often seen from a distance. These images deemphasized the wounded but offered concrete examples of the government's ability to house—and presumably care for—the victims of wounds and disease. Photographs of the convalescent camp in Alexandria, Virginia, exemplified government management of soldiers' medical care, as did the anonymous sketch of a U.S. general hospital in Portsmouth Grove, near Newport, Rhode Island (fig. 48). Hammond

Fig. 47. Ambulance train, Harewood Hospital, Washington, D.C.

Fig. 48. United States general hospital, Portsmouth Grove, Rhode Island. The painting of the general hospital by an unknown artist provides a panoramic view of the large government hospitals in the North.

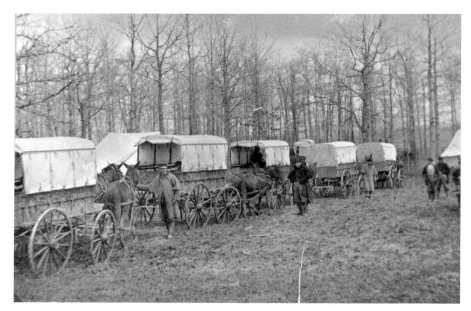

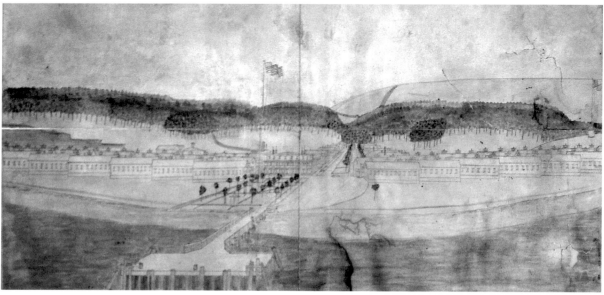

was instrumental in the founding of the hospital, and three women were appointed to oversee the nurses and the domestic operations of the hospital. The women emphasized a systematic approach to care. This involved assigning one woman to manage the nurses and oversee the care of a single ward, which included supervising cleaning and the preparation of special diets for the patients, who began arriving in January 1863 from Fortress Monroe.[9]

As the government became more skilled at transporting soldiers away from the field and into a network of hospitals that stretched steadily northward, the demand for nurses as well as hospital workers increased. Toward the end of 1863, the medical inspector for the surgeon general identified the significant need for laundry workers. It was difficult, he noted, to find sufficient hospital workers to do the laundry, resulting in the need to use washing machines or to employ private contractors, and he requested an increased appropriation "to obviate the present embarrassments."[10] The visual evidence portrays a different aspect, indicating that hospital laundry provided wartime work for women, men, and children, both black and white (fig. 49).

The convalescent camp near Alexandria was an important nexus for moving sick and wounded soldiers northward, away from the front in Virginia and closer to the distribution of supplies in the North, or for transporting convalescing soldiers who were en route to rejoining their regiments. According to one report, the camp was known as "Camp Misery" until greater efficiencies

Fig. 49. Hospital No. 9, laundry yard, Nashville, Tennessee. The photograph of the laundry yard at the hospital offers a window into the inner workings of a wartime hospital, including the array of hospital workers employed in the Union-occupied city.

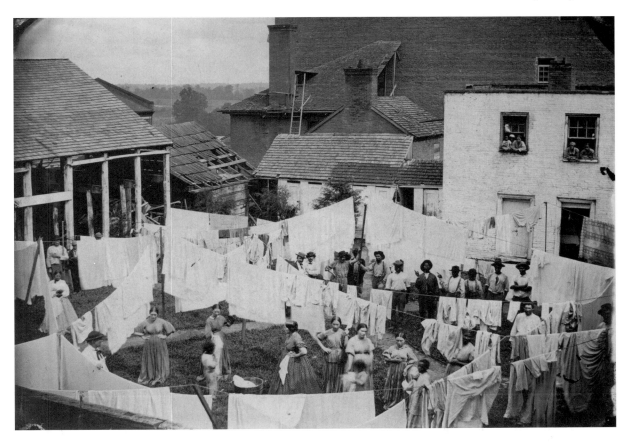

Fig. 50. Convalescent camp near Alexandria, Virginia, 1863.

Fig. 51. Convalescent camp near Alexandria, Virginia.

were enacted in 1863, aided by the work of the United States Sanitary Commission. The commission supplemented the clothing and food provided by the government to more than 111,000 soldiers who passed through the camp in 1863 (figs. 50, 51, 52, 53).

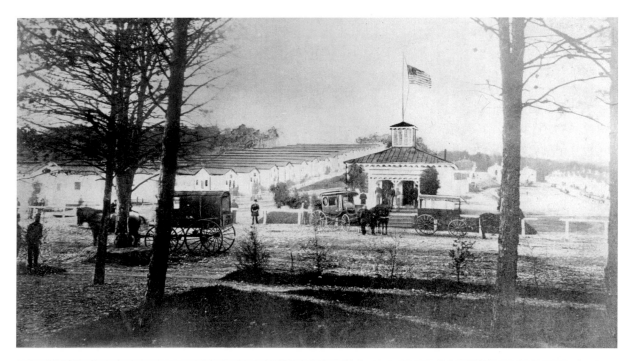

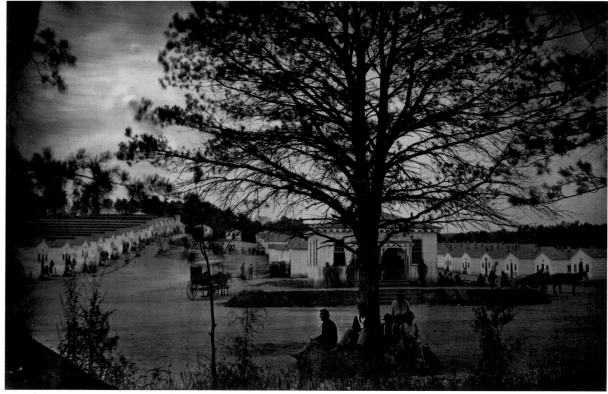

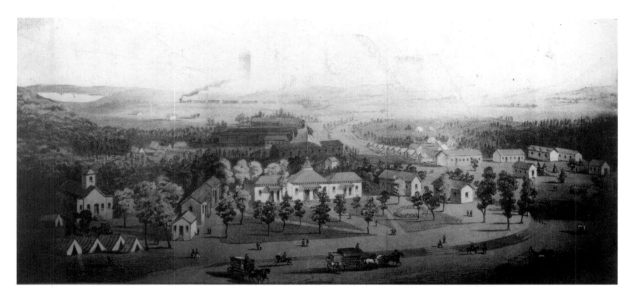

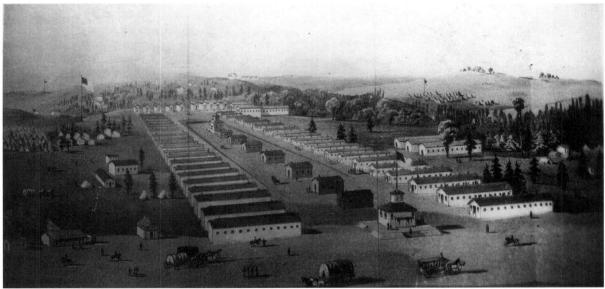

Amy Morris Bradley, a native of Maine, volunteered as a nurse for a Maine regiment when the war began and became a special agent of the Sanitary Commission at the Alexandria camp. Bradley is pictured in figure 54, in the doorway of the office, wearing a plaid dress. She reported to the Sanitary Commission in an 1863 account that detailed both her nursing and bureaucratic efforts.

I arrived on the 17th December. On the 21st, when the soldiers were all assembled in line for inspection, I passed around with the officers and supplied seventy-five men with woolen shirts; I worked on the principle of supplying only the very needy. The same day I visited the tents, and finding many sick men, induced the commanding officer to place at my disposal some hospital tents. I soon had a hospital, and commenced to nurse such poor fellows as I gathered from among the well men of the

Figs. 52 and 53. Convalescent camp, Alexandria, Virginia. The renderings of the camp at Alexandria, complete with strolling visitors, flying flags, parklike foliage, pavilion, and church, are true to photographs of the camp. Such embellishments would appeal to Northerners who wanted to celebrate the government's ability to care for its soldiers or to associate health and healing with positive images of sanitary buildings in a natural setting.

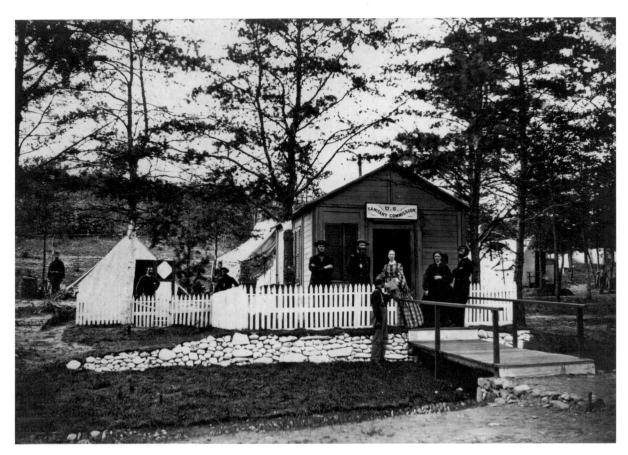

Fig. 54. U.S. Sanitary Commission, convalescent camp, Alexandria, Virginia.

camp. I found others whose discharge papers had been lying in the office for some time; these men being too feeble to stand in the cold and wet and wait their turn. I carried them to my hospital and warmed and clothed them, applied for their papers, and then sent them into Washington on the way to their homes.

Her work earned the commendation of the Sanitary Commission in their 1864 promotional history. "Similar labors are being carried on, upon a smaller scale, in connection with other places of rendezvous and at the various great centres where convalescents are gathered, but it is seldom that a woman has found such a field of labor as that which is occupied by Miss Bradley. Her peculiar fitness for the duties of 'lady superintendent' of hospital nursing and administration were proved in the Hospital Transports during the Peninsular campaign, and in her place at the Rendezvous of Distribution her labors have been above all praise." Following the war, Bradley relocated to Wilmington, North Carolina, where she was instrumental in establishing schools for African American and white children through the Freedmen's Bureau and private philanthropy.[11]

The hospital at Jeffersonville, Indiana, was across the Ohio River from Louisville and opened in February 1864 (fig. 55). It was constructed as a pavilion with twenty-four wards organized around a central corridor, with offices as

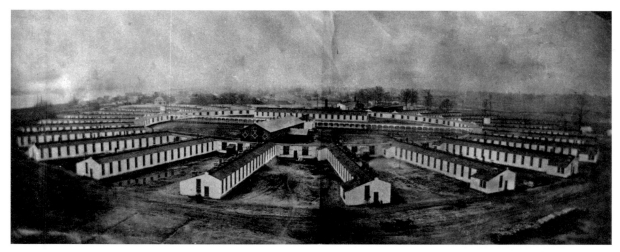

well as housing for the medical staff. Although built on the new model of general hospitals, with an emphasis on cleanliness and organization, this U.S. general hospital suffered from the hardships of other general hospitals. The flow of patients was uneven. Hundreds of men were furloughed to go home and vote in the 1864 presidential election, leaving the wards at less than half capacity. At other times, hundreds of transfers from hospitals in Nashville were moved farther north, arriving en masse. Nurses struggled to conquer government bureaucracy to procure the mattresses, shirts, and rations patients required, and their efforts were aided by private organizations, including the U.S. Sanitary Commission and loyal Union supporters in the Louisville area. These partnerships enabled the hospital to celebrate Thanksgiving in 1864 with a lavish dinner for the patients and to decorate the wards with greenery for Christmas.[12]

Photographs of Harewood Hospital in Washington, D.C., also emphasized, mostly from afar, the successful mobilization of resources to minister to the sick and wounded (fig. 56). When photographers ventured inside the hospital, they recorded institutional organization through images that were, at times, completely devoid of patients. Photographs of patients in the hospital and on the grounds were carefully staged, revealing little of the day-to-day conditions in the hospitals. In 1862, Harewood consisted of an expanded field camp, with hundred of tents comprising the wards of the hospital (figs. 57, 58). The poet and Civil War nurse Walt Whitman's account of Harewood Hospital, the last hospital that remained open in Washington, D.C, during the winter of 1865–66, revealed conditions unlike those recorded by the photographers:

December, 1865—The only remaining hospital is now "Harewood," out in the woods, north-west of the city. I have been visiting there regularly every Sunday during these two months.

January 24, 1866—Went out to Harewood early to-day, and remained all day.

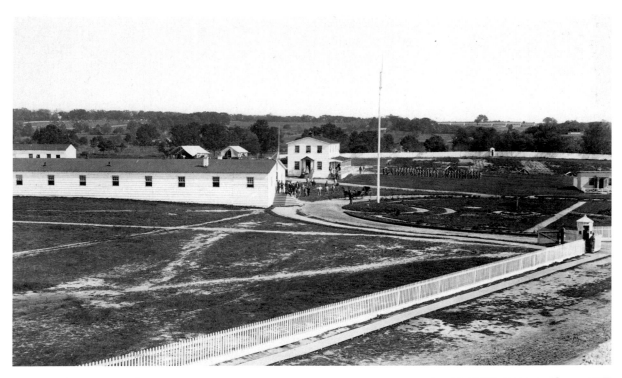

Figs. 56 and 57. Harewood
Hospital, near Washington,
D.C.

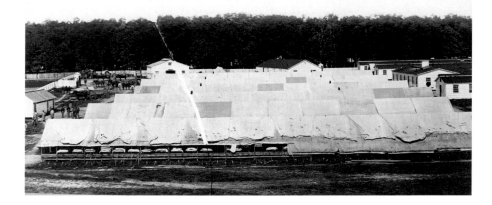

Sunday, February 4, 1866.—Harewood Hospital again. Walked out this
afternoon (bright, dry, ground frozen hard) through the woods. Ward
6 is filled with blacks, some with wounds, some ill, two or three with
limbs frozen. The boys made quite a picture sitting round the stove.
Hardly any can read or write. I write for three or four, direct envelopes,
give some tobacco, etc.

Joseph Winder, a likely boy, aged twenty three, belongs to 10th Colored
Infantry (now in Texas); is from Eastville, Virginia. Was a slave; be-
longed to Lafayette Homeston. The master was quite willing he should
leave. Joined the army two years ago; has been in one or two battles.

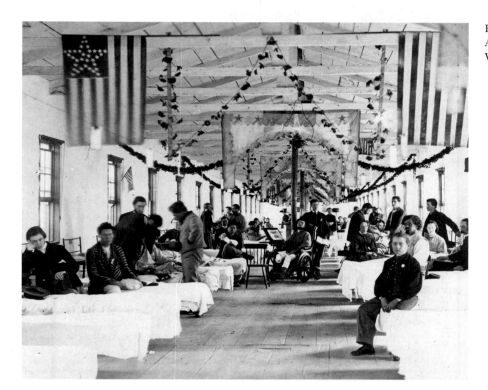

Fig. 58. Patient ward,
Armory Square Hospital,
Washington, D.C.

Was sent to hospital with rheumatism. Has since been employed as cook. His parents at Eastville; he gets letters from them, and has letters written to them by a friend. Many black boys left that part of Virginia and joined the army; the 10th, in fact, was made up of Virginia blacks from thereabouts. As soon as discharged is going back to Eastville to his parents and home, and intends to stay there. . . .

Harewood, April 29, 1866. Sunday afternoon.—Poor Joseph Swiers, Company H, 155th Pennsylvania, a mere lad (only eighteen years of age); his folks living in Reedsburgh, Pennsylvania. I have known him now for nearly a year, transferred from hospital to hospital. He was badly wounded in the thigh at Hatcher's Run, February 6, 1865.

James E. Ragan, Atlanta, Georgia; 2d United States Infantry. Union folks. Brother impressed, deserted, died; now no folks, left alone in the world, is in a singularly nervous state; came in hospital with intermittent fever.

Walk slowly around the ward, observing, and to see if I can do anything. Two or three are lying very low with consumption, cannot recover; some with old wounds; one with both feet frozen off, so that on one only the heel remains. The supper is being given out: the liquid called tea, a thick slice of bread, and some stewed apples.

That was about the last I saw of the regular army-hospitals.[13]

Photographers in the field, however, offered a different perspective, revealing the living conditions and experiences of sick and wounded soldiers. In the Peninsula campaign, James Gibson's photographs of hospitals showed makeshift field hospitals in farmhouses, tents, and yards. In September 1862, a surgeon from Massachusetts who traveled to Washington to aid in the care of soldiers, was called to Chantilly, Virginia, where Union forces were defeated by Stonewall Jackson as the Confederate troops prepared to march into Maryland. There, he reported the condition of field hospitals.

> On arriving at our place of destination, *lying about on the grass or in an old house and its outhouses*, we found about one hundred and fifty soldiers, suffering from gunshot wounds of every description, inflicted five or six days before. Two had been shot through the lungs; one through both thighs and scrotum; some through the abdomen. In short, no part of the body had escaped. Four surgeons of the army were in attendance; but from want of food and sleep they were nearly exhausted; and being unable to perform but little duty, they requested me to remove some limbs, which operations were necessary to the more favorable transportation of the wounded to Washington. These were an amputation of the thigh, for a wound of the knee-joint and compound fracture of the former; and an amputation of an arm, for compound fracture and extensive laceration at elbow-joint.[14]

After the Battle of Fair Oaks, a surgeon from Massachusetts visited the field and reported what he found to the *Boston Medical and Surgical Journal*.

> June 12th. The site of encampment was the battlefield of a previous date. The country around was scattered with human bodies and horses, in the several stages of decomposition, the water was impure, and the air pestilential. There was evident a scarcity of vegetable food while at Fair Oaks; and the labors of the regiment were very severe. Picket duties carried it every 3d day into the midst of an almost insupportable stench arising from decaying bodies and stagnant pools. Daily and nightly alarms called the men, when off duty, to arms. In addition to which, they were engaged in the armed reconnoissance [*sic*] of June 18th, which resulted in heavy loss to the regiment, and in the battles of June 25th and June 28th.[15]

One newspaper correspondent wrote of Savage Station Hospital, which received the wounded from the Seven Days' Battles:

> The poor, helpless, wounded soldiers,—how they suffer! Those away from water have inexpressible agony. Those in the wet,—how they contract new disease, and how they undergo torments from the chilly nights!

And after they are b[r]ought to the hospital, the groaning everywhere over the three acres of lawn upon which they are laid, the cries for help, for food, for drink, for shade, the delirium of the dying, the blood, discoloration, disfigurement, and dirt and wretchedness, spread all over those three acres,—an uninterrupted stream of unfortunates pouring in from

Figs. 59 and 60. House, barn, and huts used as hospitals, Smith's Farm, Battle of Antietam, 1862.

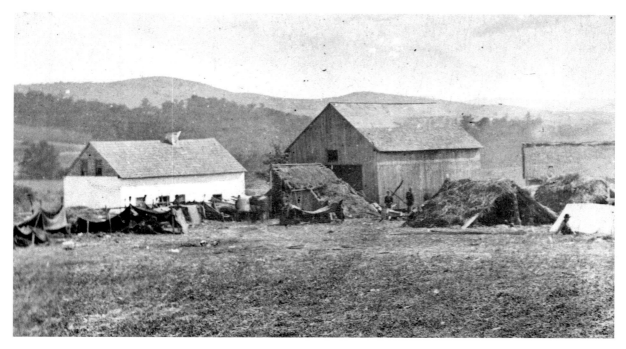

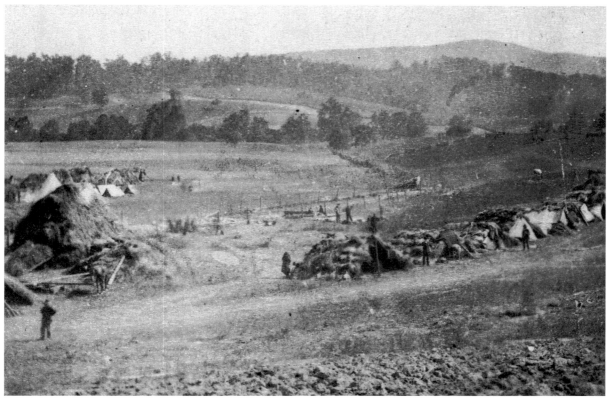

the battle-field, and another going out toward the great hospital-tent, as one by one they are taken to be cared for by the surgeons,—it is terrible. In that tent the scene is, if possible, more horrid. The ceaseless work upon the operating-table, the use of knife and probe by lantern-light, the dressing of ghastly wounds all night and all day, and the screaming of stout men under the surgeons' knives,—all this will render Savage Station a ghastly remembrance for years.[16]

At Antietam, temporary hospitals were erected from tents or established in barns and outbuildings (figs. 59, 60). At one of these, twenty-two-year-old Robert Brierly of the 1st Delaware Volunteers suffered from a wound in his lower abdomen. The bullet lodged in his right hip, near his spine, and he suffered greatly, vomiting throughout his stay. Surgeons provided him with opiates, and he was moved via ambulance service to the general hospital at Frederick, Maryland. By the end of October, his wound was open and infected. Two months later, at the end of 1862, Brierly was transferred to Baltimore and mustered out of the service and returned home, to New Castle, Delaware.[17]

Photographers from Mathew Brady's studio took photographs of the wounded who sought shade under the large trees at St. Marye's Heights in mid-May 1864 (fig. 61). These soldiers were among the casualties from Ulysses S. Grant's Wilderness campaign. In battles that ranged from the Wilderness to Spotsylvania Court House to Cold Harbor, the Federal army suffered 44,000 killed, wounded, and missing soldiers.[18]

In contrast to the rural images of field hospitals, the photograph of the

Fig. 61. Wounded soldiers at St. Marye's Heights, Fredericksburg, Virginia.

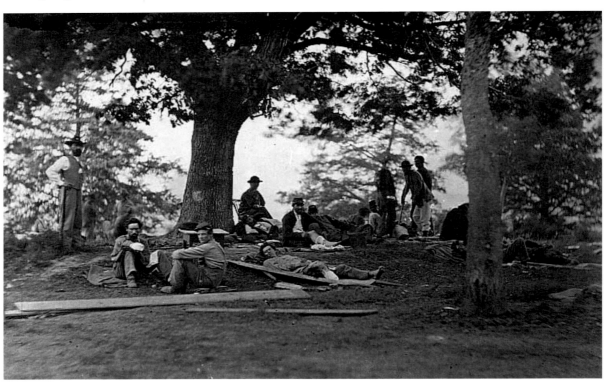

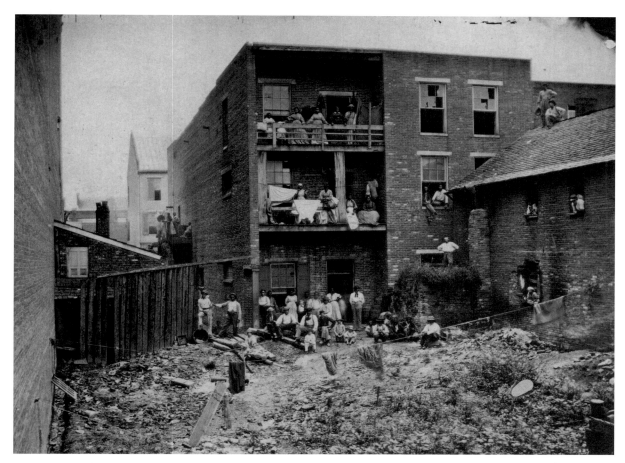

buildings surrounding Hospital No. 19 in Nashville offers a perspective on hospitals that operated in urban areas, capturing a moment in the lives of the people who lived and worked in the war-torn city, including African American women and children (fig. 62). That wartime brought difficult living conditions is palpable, and the caption notes that the buildings were leveled for the benefit of the hospital. The effect of this on the displaced residents is unknown.

Fig. 62. Hospital No. 19, Nashville, Tennessee, hospital yard.

CHAPTER
THREE

To Supply and Sustain the Troops

The Civil War called for the Union army to become adept at mobilizing and moving soldiers and supplies across vast distances and challenging geography in both the eastern and western theaters of war. It demanded the reorganization of military commands and innovations in signaling. It also called for extensive government spending. Ninety percent of U.S. expenditures went to the military during the war years. Two-thirds of all the Union war costs paid for matériel to outfit and sustain soldiers in the field. This amounted to approximately 1 billion rounds of small ammunition, 1 million horses and mules, 6 million blankets, and 10 million pairs of pants. By historians' accounts, the Union army was the best equipped and most powerful assembled to that date in history. Union quartermaster general Montgomery Meigs was responsible for outfitting an army that approximated 1 million men, and he did so with a military bureaucracy that included more than 100,000 civilian workers. While the quartermaster's department procured clothing, horses, livestock, feed, and ammunition, the departments of subsistence and ordnance spent half as much as the quartermaster.[1]

In the east, McClellan's Army of the Potomac learned that the dozens of rivers, streams, and brooks that bisected the Chesapeake region—six between Washington and Richmond alone—could impede movement or aid in amassing troops, depending on the strategy and planning of commanders (fig. 63). When McClellan began the Peninsula campaign in early 1862, the army transported more than 100,000 men, 5,000 wagons, and 25,000 animals and accompanying equipment to the land between the York and James rivers (fig. 64). The Army of the Potomac's manpower advantages over the Confederate forces were neutralized, however, by both McClellan's reluctance

Fig. 63. Defenses protecting Etowah Bridge, near Cartersville, Georgia, Western and Atlantic Railroad, 1864. This bridge was completed in 1848 and ran between Chattanooga and Atlanta. The railroad was an important strategic objective for Union and Confederate forces.

Fig. 64. Ruins of the Richmond and Petersburg Railroad Bridge, April 1865. The burning of Richmond on April 3, 1865, devastated the Richmond and Petersburg Railroad, which had enabled passengers to travel the twenty-two miles between the cities in an hour and a half before the war. By 1866, the bridge over the James River was repaired and the rolling stock was replaced at a cost of just over $250,000.

to attack Confederate fortifications and the challenging terrain. Rivers were swollen by spring rains, and the roads were thick with mud. The army relied on steamships to bring in supplies and evacuate the wounded. Engineers constructed pontoon bridges to cross waterways (figs. 65, 66, 67, 68). Yet the army suffered from inefficient ground transportation. Horses were not shipped in sufficient numbers to harness to all the wagons, which delayed movements and caused a shortage of rations. During the Army of the Potomac's retreat, confused procedures for moving the wagons resulted in the loss of roughly half the army's supply.[2]

The armies in the western theater—which were smaller than the Army of the Potomac—had distinct supply advantages over those in the eastern theater, including proximity to resources in the midwestern states made possible by river transport. Though western armies shared with the eastern armies the shortages of wagons, horses, and mules, they were mobile and maneuvered their armies through difficult terrain in 1862. The Mississippi River system in the western theater was crucial to Union and Confederate military strategy as well. The Mississippi, long a source of wealth for the Deep South, bisected the

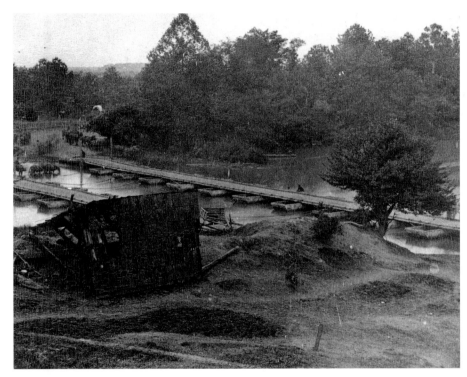

Figs. 65 and 66. Pontoon bridges over the North Anna River, Virginia, 1864.

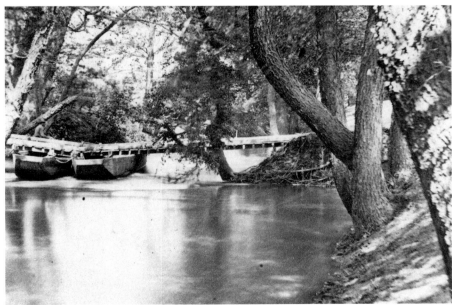

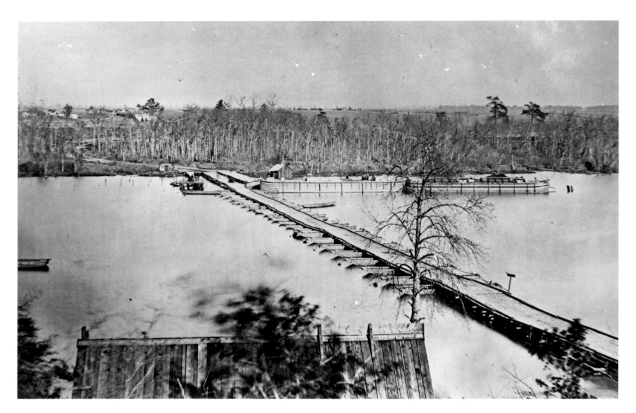

Fig. 67. Pontoon bridge over the Appomattox River at Broadway Landing.

Fig. 68. Constructing a pontoon bridge, Beaufort, South Carolina, 1862.

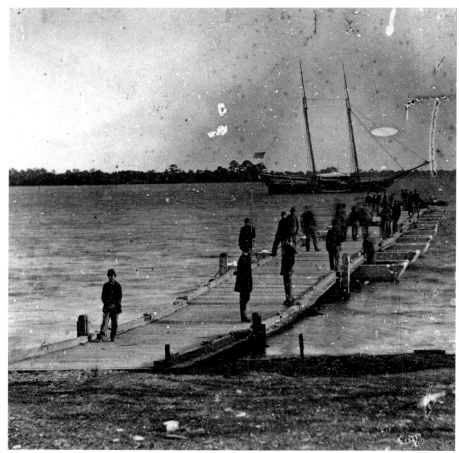

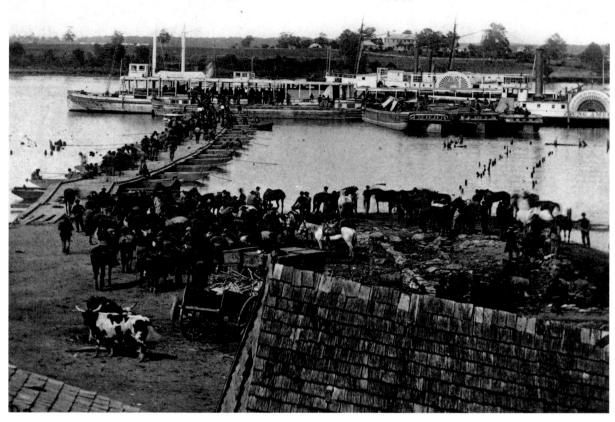

Confederate nation, rendering control of the river crucial for Jefferson Davis's government, and the Confederate military focused on defending their western interior waterways. The midwestern states, with their greater capacity for industry, produced more river vessels than the Confederacy, giving their armies an important advantage. In the first half of 1862, the Union army advanced into Tennessee, Mississippi, Alabama, and Louisiana by using water transports to ply the watery arteries of the Confederacy. They secured fifty thousand square miles of territory, one thousand miles of rivers, the city of New Orleans, and vital railroad lines running east to west across the Confederacy. The Confederates maintained their hold over the river from Vicksburg, Mississippi, to Port Hudson, Louisiana, until the summer of 1863. In July of that year, Vicksburg fell to Union forces under the leadership of Ulysses S. Grant, and the Union secured Port Hudson, opening the Mississippi River for the use of Union military transports, floating hospitals, supply ships, and commercial vessels.[3]

The Union army relied on railroads, along with water transport and teams of animals, to move troops and supplies during the war (figs. 69, 70, 71). The military use of the railroad suffered from inefficiencies in the war's first year.

Fig. 69. Evacuation of Port Royal, Virginia, along the Rappahannock River, May 30, 1864. Following reverses at Spotsylvania, Grant ordered his base of supplies moved as he embarked on a series of flanking maneuvers around Lee during late May 1864. The supply base was relocated to White House, Virginia, along the Pamunkey River.

Fig. 70. Union transport, Tennessee River.

Fig. 71. The *Aleck Scott*, Cairo, Illinois. Recalled years later by Mark Twain as a "stately craft," the *Aleck Scott* was built in St. Louis in 1848 and plied the Mississippi River, transporting goods and people from Cairo to New Orleans. In 1862, the ship was converted for navy use as an ironclad and renamed the USS *Lafayette*. It ran the guns at Vicksburg successfully in 1863 and patrolled the Mississippi and Red rivers.

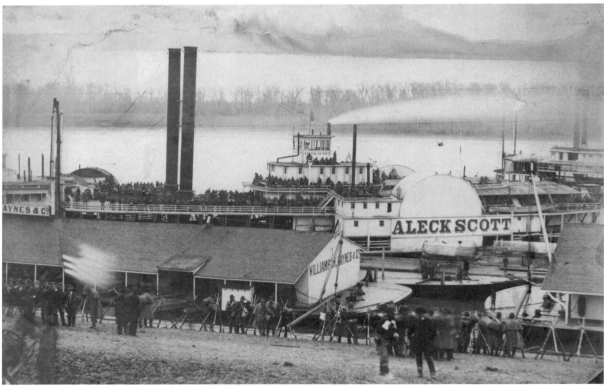

In January 1862 an act of Congress authorized the president to impress railroad equipment and place railroad officials under military authority. When the War Department established the United States Military Railroad the following month, Lincoln delegated authority to the military superintendent of the railroad, D. C. McCallum. Lincoln's executive order gave McCallum the power to undertake all measures "speedy and proper" to transport troops and supplies, including seizing rail lines, engines, and rolling stock (figs. 72, 73, 74). Railroads, however, were vulnerable in war. As the Union army ad-

Fig. 72. United States Military Railroad, Loudon Line, near Washington Junction, 1863.

Fig. 73. Railroad Depot, Culpeper Court House, Virginia.

vanced into Confederate territory, it used railroads to move troops and supplies through rural and often isolated regions and focused strategy on capturing significant railheads, such as Chattanooga and Atlanta. The Confederate military strove both to defend its railroads and to disrupt those of the enemy. While the former proved daunting, in the latter they were maddeningly effective (figs. 75, 76, 77, 78).

William Tecumseh Sherman bemoaned the vulnerability of the railroad throughout the war. In October 1861, he defended Muldraugh Hill, south of Louisville, a critical point on the railroad from Louisville to Nashville. In a

Fig. 74. United States Military Railroad locomotive. This photograph shows both the engine used to transport men and supplies and the challenges varied terrain posed for railroad workers who were charged with securing, maintaining, and repairing the rail lines.

Fig. 75. United States Military Railroad engine overturned by rebels.

letter to his brother, Ohio senator John Sherman, he wrote, "We have 5,000, and the Railroad behind is guarded by three more, but this road can be cut at a hundred different points which would starve us out or force me to strike out and live on a country which produces only beef and corn." A month later, he wrote that although he controlled the railroad, "a child or man with a crowbar may destroy it." By the close of the year, Sherman expressed his frustration with the Confederate strategy of attacking the rail lines in the countryside. "These railroads are the weakest things in war; a single man with a match can

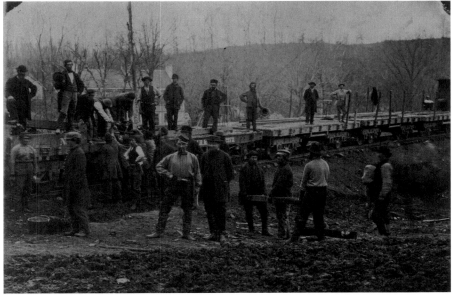

Fig. 76. Ruins of a railroad bridge at Bull Run.

Fig. 77. Clearing wreck of a train burnt by rebels, Bull Run. The workers on the U.S. Military Railroad load the wreckage of trains destroyed by Confederate forces in April 1863.

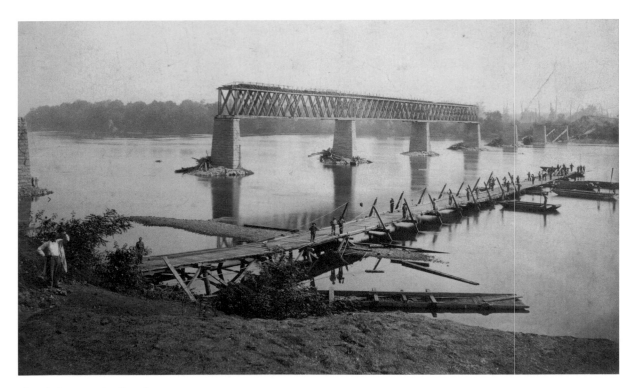

Fig. 78. Destroyed railroad bridge, Bridgeport, Tennessee.

destroy a bridge and cut off communications, and no one seems to apprehend the danger by laying in supplies accordingly" (fig. 79). Three years later, Sherman complained about the manpower required to guard the lines.

> I still hold Atlanta in strength, and have so many detachments guarding the railroad that Hood thinks he may venture to fight me. He certainly surpasses me in the quantity and quality of cavalry, which hangs all around and breaks the railroad and telegraph wires every night. You can imagine what a task I have, 138 miles of railroad, and my forces falling off very fast. I hear some new regiments are now arriving at Nashville, and they may strengthen my line so that I may go ahead, but Mobile or Savannah should be taken before I venture further. I am far beyond all other columns.[4]

To meet the need to rebuild and repair the railroads, bridges, and machinery necessary, Secretary of War Stanton placed West Point-educated railroad engineer Herman Haupt in charge of the military railroad. Haupt made his headquarters in Alexandria, where the Orange and Alexandria Railroad met the Loudon and Hampshire line. There he oversaw railroad engineering and construction projects, including the reconstruction of bridges destroyed by the Confederates (fig. 80). The U.S. Military Railroad operated in the Southern states beginning in 1862. As armies in the field moved, so did the railroads, as rail lines were repaired, built, connected with each other, and abandoned as the war's needs dictated (figs. 81, 82, 83). The vast resources in Alexandria

made such adaptation possible. In Alexandria, engineers constructed models, prefabricated parts of bridges, moved loaded railroad cars by barge over water, supplied lumber and rails, and warehoused the materials when they were sent back from the field (figs. 84, 85). By the close of the war, almost ten thousand workers were employed in the construction corps in the east and west, under

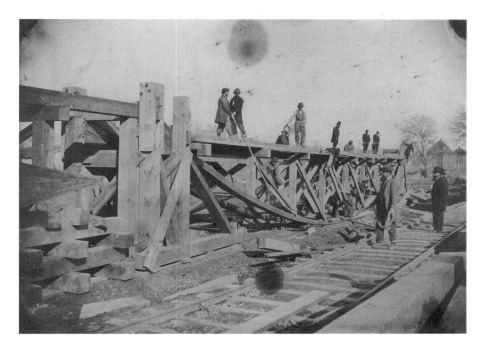

Fig. 79. United States Military Railroad yard, Alexandria, Virginia. Experimenting with bridge construction in the government yards enabled the workers on the military railroad to support Union troop movements. In 1864, the military railroad workers maintained a 360-mile supply line behind William Tecumseh Sherman's army as it advanced on Atlanta.

Fig. 80. Rebuilding a bridge on the Orange and Alexandria Railroad, Virginia.

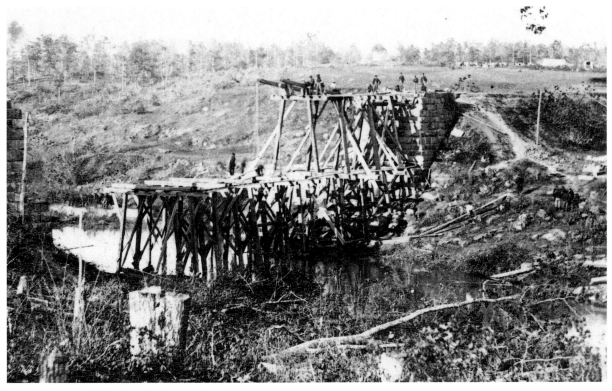

Fig. 81. Ruins of the North Eastern Railroad Depot, Charleston, South Carolina, 1865. In 1866, Boston journalist Charles Coffin described what ensued when fleeing Confederate forces fired the cotton at the depot: "At the Northeastern Railroad depot there was an immense amount of cotton which was fired. The depot was full of commissary supplies and ammunition, powder in kegs, shells, and cartridges. The people rushed in to obtain the supplies. Several hundred men, women, and children were in the building when the flames reached the ammunition and the fearful explosion took place, lifting up the roof and bursting out the walls, and scattering bricks, timbers, tiles, beams, through the air; shells crashed through the panic-stricken crowd, followed by the shrieks and groans of the mangled victims lying helpless in the flames, burning to cinders in the all-devouring element."

Fig. 82. Disabled engines taken from rebels, 1863, United States Military Railroad yard, Alexandria, Virginia. The scarcity of iron, spare parts, and labor made it difficult for the Confederacy to replace rolling stock when it was captured by Union forces.

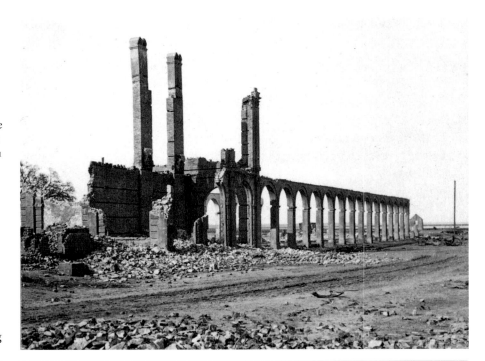

the supervision of engineers, and provided with the materials and tools to maintain the railroads. In Virginia alone, engineers and contractors rebuilt more than six miles of bridges and laid more than 177 miles of rails. When Sherman marched to Atlanta, the construction corps worked apace, rebuilding the railroad from Chattanooga to Atlanta (fig. 86). They dismantled parts of it, shipping the rails back to Chattanooga when Sherman moved on to Savannah. By the end of the war, the U.S. Military Railroad encompassed more than two thousand miles of railroad, including former Confederate lines and new railways constructed by the U.S. Military Railroad. In the months following Appomattox, the engineers and construction corps repaired railroads and

Fig. 83. United States Military Railroad yard, Alexandria, Virginia. Scrap iron from damaged railroad engines and cars, 1863. The workers on the military railroads were tasked with preventing useful railroad resources from falling back into Confederate hands.

Fig. 84. United States Military Railroad, Catlett's Station, Virginia. The depot along the Orange and Alexandria Railroad was used as a Union base of supplies when on August 22, 1862, Confederate cavalry, led by J. E. B. Stuart, surprised General Pope's rear guard. The cavalry raid captured the Union supply train, which included the general's personal baggage, but did not burn the nearby railroad bridge, owing to a rainstorm.

bridges, and in August 1865, the various rail lines were turned back over to their state, municipal, or private ownership.[5]

In addition, river travel was imperative to the Union's military campaigns for both providing supplies and evacuating the wounded. In the western theater, the waterways provided access for Union troops as they sought to divide the Confederacy.

In 1862, after victories at Forts Henry and Donelson, the Union army advanced into northern Alabama and occupied territory along the Tennessee

River. Confederates regained the territory, but when they withdrew to fortify eastern Tennessee in the summer of 1863, Union forces returned and made Bridgeport, Alabama, a central base of supplies. Both the railroad and the Tennessee River aided the movement of troops and supplies at Bridgeport, and the Union army constructed ships at Bridgeport as well, including the USS *Bridgeport,* shown in 1864 shortly after its construction (fig. 87).

Fig. 85. United States Military Railroad yard, Alexandria, Virginia. Army engineers built models of bridges in the rail yard so they could construct, and destruct, bridges with greater efficiency in the field.

Fig. 86. Bridge over the Tennessee River at Chattanooga, Tennessee. The work of military engineers is evident in the wooden trestles and supports of the bridge.

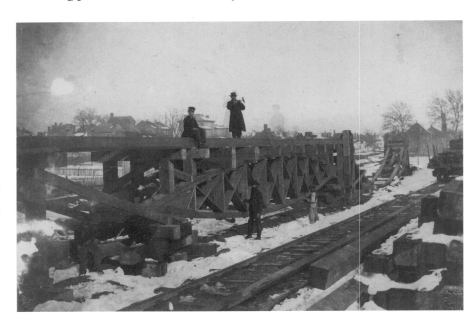

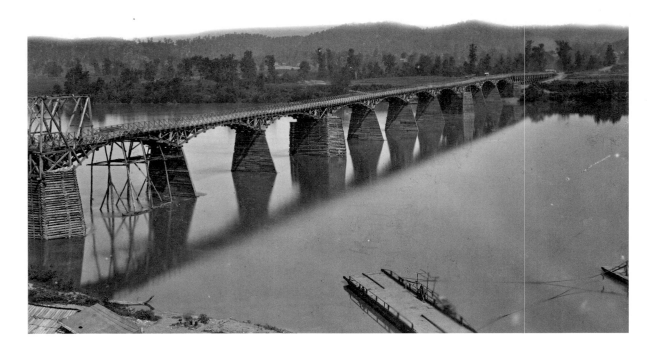

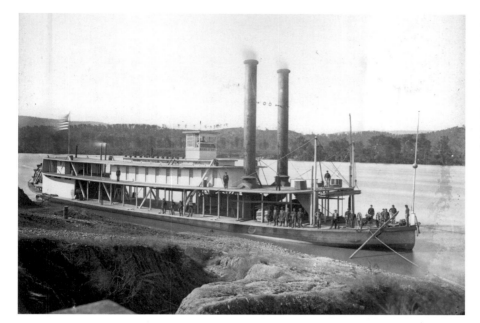

Fig. 87. The USS *Bridgeport* on the Tennessee River, Bridgeport, Alabama.

Fig. 88. Railroad Depot, Hanover Junction, Pennsylvania. The Hanover Branch Line was completed in 1858 and ran between Hanover Junction and Gettysburg.

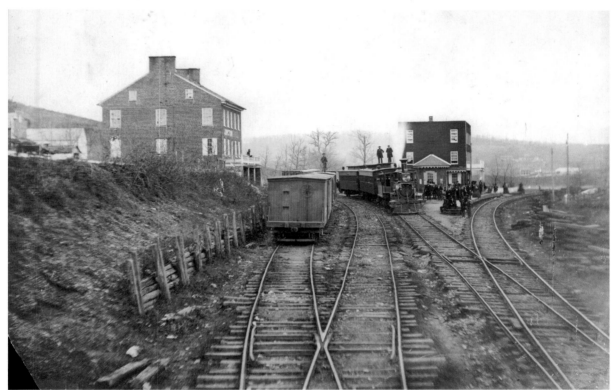

In July 1863, the Union army took control of the railroad between Hanover Junction and Gettysburg, a distance of thirty miles, and used it to transport more than fifteen thousand wounded men to general hospitals (fig. 88). The railroad construction corps also repaired the railroad lines in Pennsylvania that had been destroyed by Confederate forces in the month before the battle.

Alexandria, Virginia, was a main supply depot during the war, accessible by the Potomac River, which separated it from Washington, D.C.; the city

was accessible by rail as well. Hospitals, warehouses, depots, lumberyards, machine shops, and coal yards were all found in and around Alexandria, as was a government bakery (figs. 89, 90, 91). The bakery, which was built next to the rail line, employed an estimated two hundred men in a facility that was one acre in size. Five hundred barrels of flour were made into an estimated ninety thousand 22-ounce loaves in twenty ovens daily. Each soldier received 22 ounces of either flour or bread every day, and the government saved an estimated three thousand barrels of flour per month by baking the bread rather than issuing flour rations.[6]

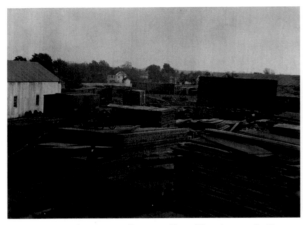

Fig. 89. United States Military Railroad lumberyard, Alexandria, Virginia. The government demand for lumber for construction was felt in distant places, such as the Caribbean islands, where observers noted that lumber shipments from America were scarce.

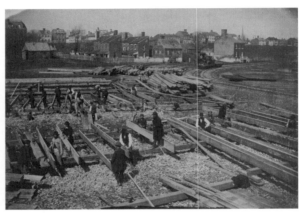

Fig. 90. United States Military Railroad lumberyard, Alexandria, Virginia. The government had sufficient stores of lumber stockpiled at Alexandria that by the end of 1865 it had a surplus of 2.5 million board feet that it offered at public sale.

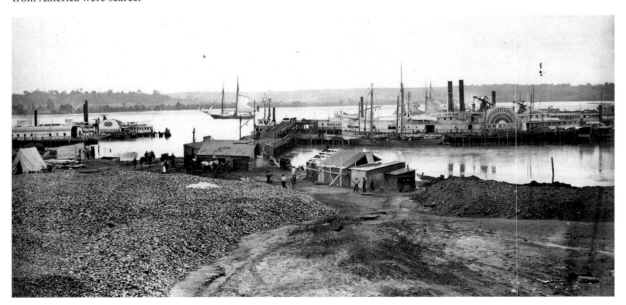

Fig. 91. Government coal wharf, Alexandria, Virginia. The price of coal, and the profits made by coal corporations, increased in the Civil War North in response to the demand for fuel. By 1864, the price of anthracite coal, adjusted for wartime inflation, was 45 percent higher than it had been in 1860. High prices spurred a mania for incorporating coal companies and fostered close relationships between coal and railroad corporations.

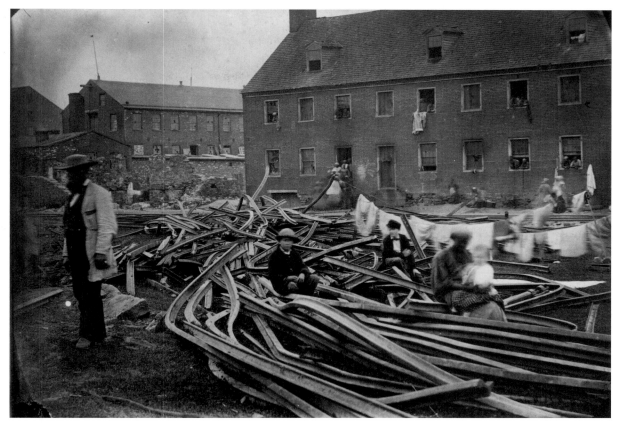

Fig. 92. Contraband quarters and damaged railroad iron from the Loudon Line, Alexandria, Virginia, June 1863.

The photographs taken in the vicinity of Alexandria, Virginia, and Washington, D.C., offer visual evidence of the Union's massive mobilization of resources. Some photographs also offer glimpses into how the war shaped civilian lives. The burnt and twisted iron, piled in the factory yard, represents a loss to the Confederate government and a gain of matériel for the Union. It also represents a source of work, or perhaps an easy place to rest, for the young boys who sit astride the rails. In the foreground of figure 92, an African American woman, among those deemed "contraband" by both the army and the government, sits on the same rails, with a light-skinned child on her lap. Behind her, African American women live in the barren and broken warehouse, hanging their laundry to dry on the open sills, including the small attic garret. As the government strained and then adjusted to the vast demands for matériel to wage war, civilians—including African Americans—were drawn to government installations where they found opportunities to work in the project of supplying the Union army in the field.

By 1864, when Ulysses S. Grant took command of the Union armies and made his headquarters with the Army of the Potomac, government efficiencies in supplying the army made it possible for armies to advance through difficult terrain and move in advance of their base of supplies. Wagon trains moved more efficiently, baggage was strictly limited, men carried more of their rations, and pack animals carried rations and forage—a critical factor in an area

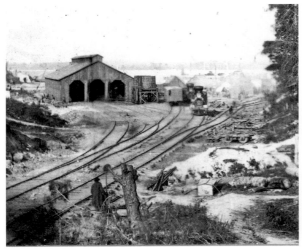

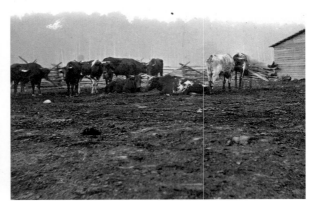

Fig. 93. City Point, Virginia. United States Military Railroad depot.

Fig. 94. City Point, Virginia. Cattle corral.

Fig. 95. City Point, Virginia. African Americans unloading supplies.

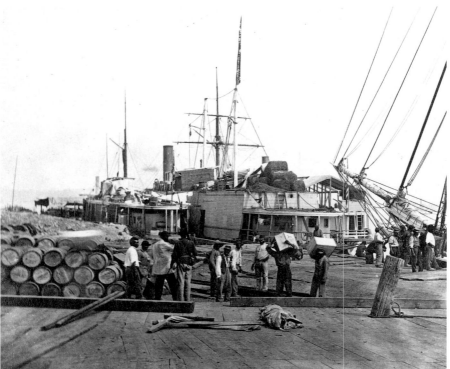

stripped of resources by an almost continuous military presence over the course of the war. Moreover, the forward supply bases proved critical to the logistics of the campaigns in Virginia. When Grant began his campaign against Petersburg in 1864, City Point, Virginia, served as his base of operations (figs. 93, 94, 95, 96, 97, 98). Located at the confluence of the James and Appomattox rivers, the former tobacco depot became a major base of supplies that allowed men and materiel to move via waterways while maintaining access to Washington, D.C. The City Point Railroad connected the rivers with Petersburg. The Union army seized control of the point in May 1864 and engaged in a rapid buildup of the base that would sustain more than 100,000 soldiers as they advanced on Petersburg.

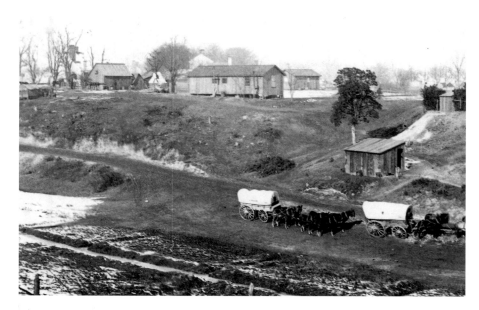

Fig. 96. City Point, Virginia. Supply wagons of the Second Corps.

Fig. 97. City Point, Virginia. Laborers' camp.

Fig. 98. City Point, Virginia. Camp of Construction Corps, United States Military Railroad. Both the railroad and the Tennessee River aided the movement of troops and supplies at Bridgeport, and the Union army constructed ships at Bridgeport as well, including the USS *Bridgeport*, shown in 1864 (fig. 87) shortly after its construction.

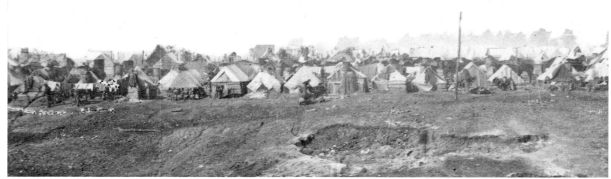

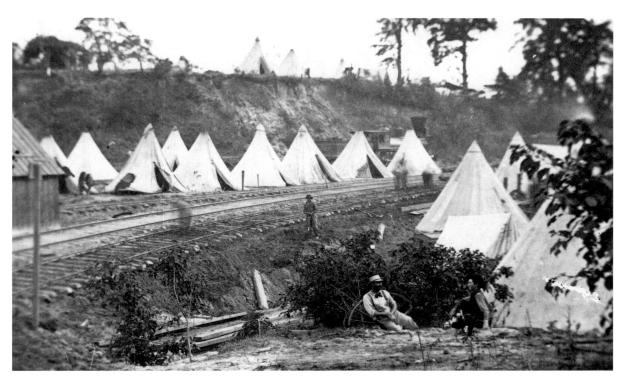

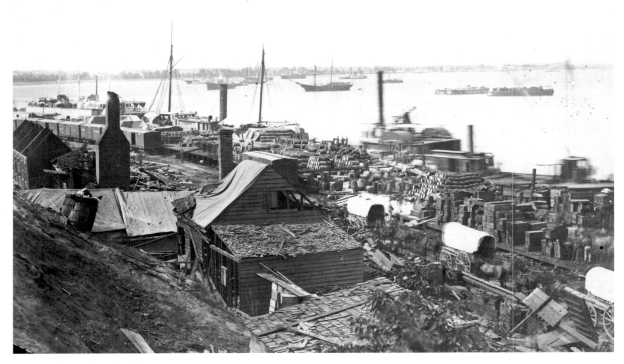

Fig. 99. City Point, Virginia. Wharf after the explosion of Ordnance Barges.

On August 9, 1864, two Confederate agents planted a bomb onboard an ammunition barge at City Point. The explosion killed forty-three people, injured more than one hundred more, and decimated the wharf (fig. 99). Within nine days, however, the depot was rebuilt and continued as a supply base for the Union army.

Seeing the Land: Images of War and Landscape

The Americans who lived during the Civil War were bound closely to the land. For not only those who lived in rural America but also those who lived in growing cities, land was central to agricultural production, but it represented as well ideals that were important to a nation that was becoming industrialized—albeit at different rates. American culture in the 1860s was suffused with images of geographic places and the natural world in literature, art, and language. As industrialization emerged in nineteenth-century America, and with it increasing urban spaces, Americans embraced the genre of the landscape as a way to celebrate their communities, to revel in the natural world, and to be transported to distant places. The landscape also captured social and economic relationships, whether by casting the growth of towns and cities in an organized, orderly, and positive fashion or by providing consumers with pastoral images to adorn their homes' interiors.[1]

By the 1820s, lithographs of villages and cities from a bird's-eye view saturated the marketplace. These visual representations were the most popular lithographic genre of the nineteenth century. Moreover, prewar stereoscopic views familiarized Americans with distant and foreign places, allowing them to visually travel the world. With such a vibrant market for landscape images before the war, it was not surprising that vast numbers of Civil War photographers emphasized landscape views as they traveled with the armies and took photographs of battlefields, encampments, and occupied communities. Photographers and engravers translated scenes for viewers far distant from the camps and sites of war. Whether in Brady's galleries or in the pages of *Frank Leslie's Illustrated Newspaper* or *Harper's Weekly,* civilians could travel along with soldiers in the field. Soldiers who returned from war could memorialize where they

had camped, marched, and fought. The families of those who perished could view the places their loved one had been. Photographs and engravings of the landscape served military purposes as well. The Department of the Gulf, for example, had two photographers in its topographical department, W. H. Browne and Walter Ogilvie. Cartographers and lithographers translated visual representations into maps for the Union army as well as for the civilian market.[2]

The representations of land and the ideas of warfare produced tensions that were evident in many Civil War photographs. Nineteenth-century artistic conventions romanticized war, emphasizing the heroism of individuals and of victory. The scale of human carnage, the unpredictability of death in camp as well as combat, the death of soldiers in places distant from their family and communities, and the armies' struggle to bury the dead all challenged heroic views of the fields of war. The Connecticut Congregational minister Horace Bushnell tried to make sense of the bloody landscapes of war. "[The soldiers] reverse, how touchingly, the fable of Antaeus. Instead of receiving from the earth, when they touch it, a great strength, they give to the earth, as it takes their blood, a new inspiration for all brothers in learning for long ages to come."[3] In a culture that was sustained by the land, Civil War–era Americans had a strong appetite for pictures of the places where soldiers camped and battles were fought. They were mesmerized by images of dead bodies, strewn amid an agrarian landscape, and they observed in photographs measures of the war's destruction on the land. In the years that followed, they perceived the destruction of the landscape even as they witnessed evidence that the land

Fig. 100. Anderson, Tennessee. The Nashville and Chattanooga Railroad was completed in 1854, which reduced the travel between the two cities to nine hours. Connecting with a rail line to Louisville, the railroad was an important supply line during the war and would play a significant role in rebuilding the economy of the postwar South.

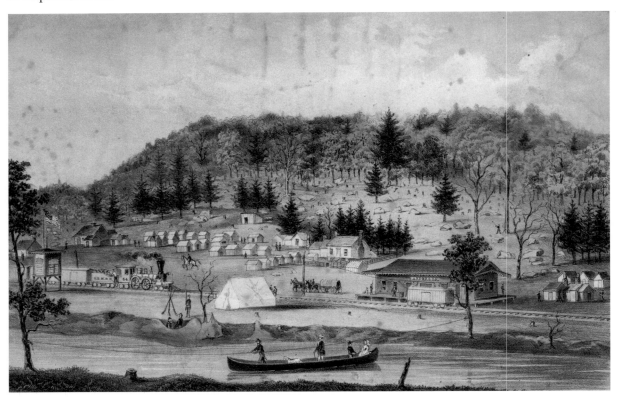

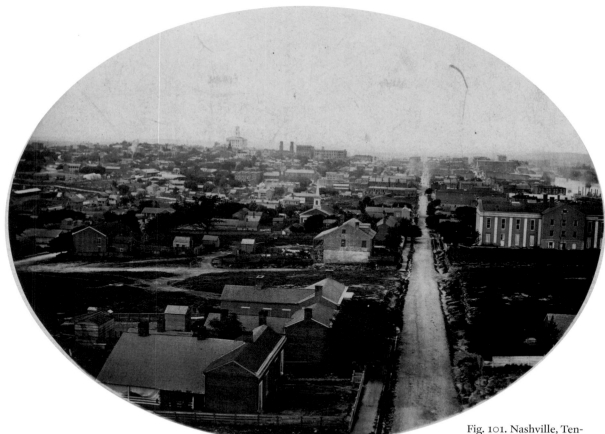

Fig. 101. Nashville, Tennessee, 1863. This view of Nashville, with the state capitol in the distance, provides a panoramic view of the city that was captured by the Union army on February 25, 1862. Although Confederate forces under Gen. John Bell Hood advanced to within miles of the city, the Union turned back the advance in the Battle of Nashville, December 15–16, 1864.

was regenerating itself—as if, in Bushnell's vision, the blood of their soldiers had nourished the land and allowed a new nation to be born.

A lithograph of Anderson, Tennessee, shows Union tents along a hillside on the banks of the Tennessee River (fig. 100). The U.S. Military Railroad runs unencumbered, along the Nashville and Chattanooga Railroad, past an army guardhouse. In the foreground, a soldier courts a woman in a boat. Though the hills show marks of deforestation, the image reveals neither the warfare practiced by both armies and guerrillas nor the tedium soldiers complained of as they maintained the crucial supply line for Union forces in eastern Tennessee and northwestern Georgia (figs. 101, 102, 103, 104, 105).

Depictions of sites of battles could be as idealized as wartime encampments. A lithograph of the Battle of Pittsburg Landing, or Shiloh, printed in 1862 by a Connecticut lithographer, shows a landscape transformed by battle. Rivers carry troop transports to the banks as horses lay dead in fields no longer demarcated by orderly fences (fig. 106). As Northerners learned of the battle, the printer capitalized on a market for renderings of the field, depicting Union forces in a state of advance, notwithstanding casualties. As public opinion in the North grappled with reports of Union retreat and soldiers' cowardice in battle, such images provided an opportunity to recast judgments

Fig. 102. Panoramic photograph, Columbia, Tennessee, 1863. The city along the Duck River was laid out in 1807. At the outbreak of the war, Columbia was best known as the home of President James K. Polk. The small city was the county seat of Maury County and served as a center of trade for the rich agricultural region that surrounded the city. Boosters praised it as a center of learning, owing to the presence of Jackson College and two seminaries for women. The city could also boast railroad connections with Memphis, Nashville, and Chattanooga, with connections to railroads that reached the Atlantic Seaboard. This feature, as well as its location southwest of Nashville, placed it in the path of Union forces into the Deep South in the spring of 1862. Union soldiers occupied Columbia until Confederate forces forced their retreat in late November 1864, as Confederates attempted to retake central Tennessee.

Fig. 103. Chattanooga, Tennessee, 1863. The photograph of a Chattanooga streetscape captures the rugged nature of the eastern Tennessee city with its low-slung buildings surrounded by a mountainous landscape. After the Union defeat at the Battle of Chickamauga on September 19–20, 1863, the Confederate forces used the terrain to its advantage, laying siege to the Union army that had retreated to Chattanooga. From November 23 through 25, a reinforced Union army succeeded in routing Confederates at the Battles of Orchard Knob, Lookout Mountain, and Missionary Ridge, forcing the Confederates to retreat into Georgia.

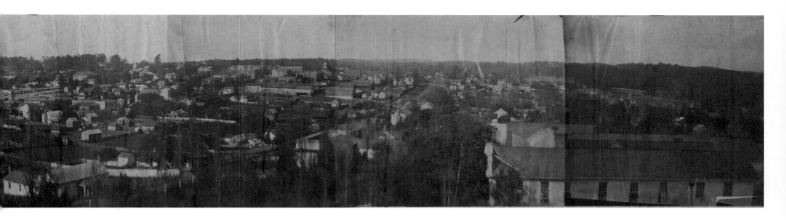

Fig. 104. Chattanooga, Tennessee, railroad depot. The city's location along the Tennessee River and at the junction of rail lines that linked the eastern and western theaters of war made the city a major Union objective. Lookout Mountain is in the distance.

Fig. 105. Chattanooga, Tennessee. Union soldiers occupied the city in the final two years of the war, when it served as a major base of supplies for Union forces.

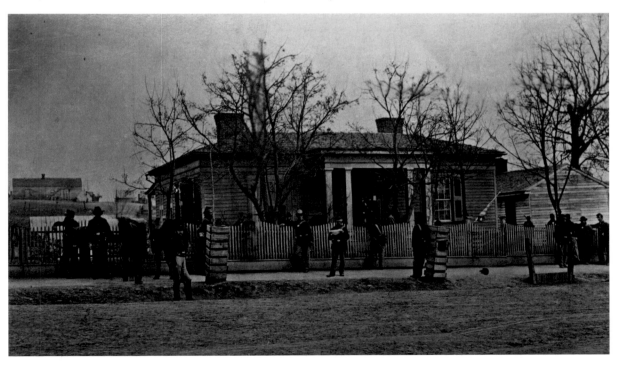

Fig. 106. The Battle of Pittsburg Landing. Lithograph, 1862.

about the battle. Five months after the Battle of Shiloh, images taken at Antietam revealed a landscape marked by war.

The Battle of Antietam, on September 17, 1862, proved to be the deadliest day in American combat history. Twenty-three thousand dead and wounded lay in the field, and it took weeks to bury the dead. The stench of rotting bodies—both human and animal—pervaded the area long after the battle. One observer recalled the stark contrast between the land and the battle that was fought there.

> The valley of Antietam is a luxurious part of Maryland; the ground admirably adapted to the successful massing of troops in reserve, as they could be shielded behind the numerous knolls from the artillery fire on either side,—as well as to the free and fair engagement of the contending infantry, when the lines came in close proximity. The undulating nature of the ground furnished fine positions to both parties for artillery, while the beauty of the surrounding scenery—the trees beginning to show their rich autumnal tinges—threw a halo of enchantment over what was now, at once, the garden and the battle-ground of Maryland. . . . Away, in every direction, hills covered with splendid corn and clover fields, vales rich with the summer's harvest, and orchards laden with ripening fruit, spread out before our view. It almost seemed at times, during the cessation of the firing, that many engaged in the bloody fray would turn from the scene of carnage to contemplate the lovely valley and its surrounding scenery.[4]

The photographs taken by Alexander Gardner and James Gibson of the Antietam battlefield went on display at Brady's New York gallery, jarring yet mesmerizing the Northern public. The graphic images of dead soldiers and graves brought the carnage of war to civilians at home. The photos also highlighted the relationship between human carnage and the landscape of battle. Dead soldiers were seen alongside a rail fence on the Hagerstown road— fences laboriously built and maintained to demarcate property and protect crops. Similar fences were destroyed across the field by charging soldiers. Days after the battle ended, soldiers were detailed to gather remains across the land, to turn the soil, and to bury the dead. The photographs of Antietam also capture the battle's impact on the buildings and houses that ordered the agricultural landscape (figs. 107, 108, 109).

After the Battle of Gettysburg, Alexander Gardner and Mathew Brady and their associates traveled to the battlefield. Gardner arrived first, on July 5, and took pictures of the dead that lay scattered on the field. Brady arrived later, likely by July 15.

The wheat field owned by George Rose along the Emmitsburg road was the site of fierce fighting on July 2 when Union and Confederate soldiers clashed repeatedly on the nineteen-acre parcel. The fighting resulted in more

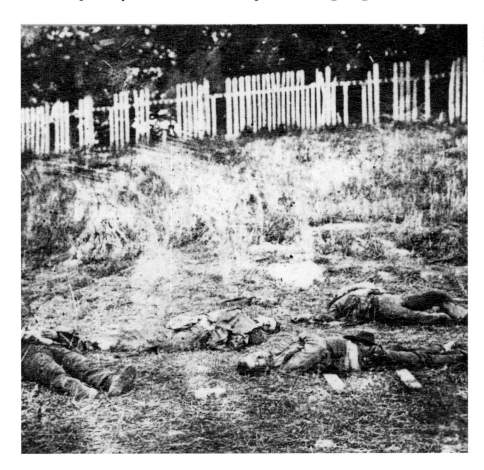

Fig. 107. Antietam, Maryland. Confederates dead by a fence along the Hagerstown road, September 1862.

than four thousand casualties, many of whom remained on the field when Gardner's photographers arrived three days later.

The photographs of the breastworks on the left of the Union line, on the elevated ground that rose to Little Round Top, document the strategic importance of higher ground as well as the scars that battles left on the landscape as soldiers cut timber and brush and moved stones in their efforts to protect their lines (figs. 110, 111).

John Burns was celebrated in the Northern press as the only civilian who fought in the battle. The photograph by Brady's photographers reveals Burns

Figs. 110 and 111. Gettysburg, Pennsylvania, breastworks on the left wing.

in his doorway, with Brady sitting close by on the back steps, his tripod camera on the ground below (fig. 112). The photograph was transformed into an engraving for *Harper's Weekly*, which moved Burns from the doorway to the action in the yard.

As photographers' lenses captured land that was marked by fortifications, carnage, and even the photographic technology that made the documentation possible, they also recorded the processes by which the dead were returned to the land and the land absorbed the human cost of war. In May 1864, following the Battle of Spotsylvania Court House, Virginia, photographers took pictures of the Union dead awaiting burial at nearby Fredericksburg. African American men dug graves in rows that paralleled the white picket fence that had served another purpose before the war but now divided the burial ground from the buildings beyond (fig. 113). At City Point, Virginia, thousands of dead Union soldiers, along with some Confederate soldiers, were buried at different cemeteries. By 1868, the cemeteries were consolidated into the National Cemetery at City Point, where 5,156 soldiers were laid to rest. The identities of 1,403 soldiers, including 587 African American soldiers, were unknown (fig. 114).

War altered the natural landscape when soldiers seized natural and man-made materials to shield them in battle. It interrupted the rhythms of daily life in places like Gettysburg. It demanded that bodies be gathered, possibly identified, and returned to the land in ordered rows. Photography documented these processes for Americans, and in response Americans looked at the photographs but also cast their eyes away to the lithographs and engravings that offered alternatives to the photography's realism. Idealized drawings showed valor with less sacrifice, courage with less carnage.

The Battle of Lookout Mountain was celebrated in the Northern press as the "Battle above the Clouds" (figs. 115, 116, 117). Following the Union's defeat at Chickamauga on September 19–20, 1863, Maj. Gen. William S. Rosecrans's Army of the Cumberland retreated to Chattanooga. The city, located in eastern

Fig. 112. Gettysburg, Pennsylvania. John Burns's house with photography equipment.

Fig. 113. Fredericksburg, Virginia. Burial of the dead.

Fig. 114. City Point, Virginia. Soldiers' cemetery.

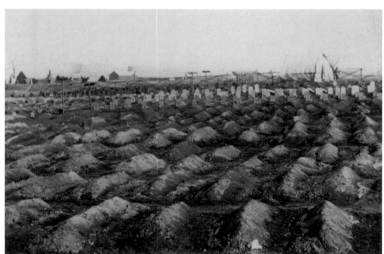

Tennessee among the Cumberland Mountains, was strategically critical; four railroads ran through the city that provided access into the Confederate interior. After Chickamauga, Confederate general Braxton Bragg and the Army of the Tennessee laid siege to the city. Confederates fortified Lookout Mountain to the southwest and Missionary Ridge to the east. From these points above the city and the Tennessee River, Bragg's forces cut off all but a single and difficult Union supply line. Lookout Mountain rose more than 1,600 feet above the river, with a sixty-foot escarpment near the summit. On the morning of November 24, Union forces began to move up Lookout Mountain in a drizzly

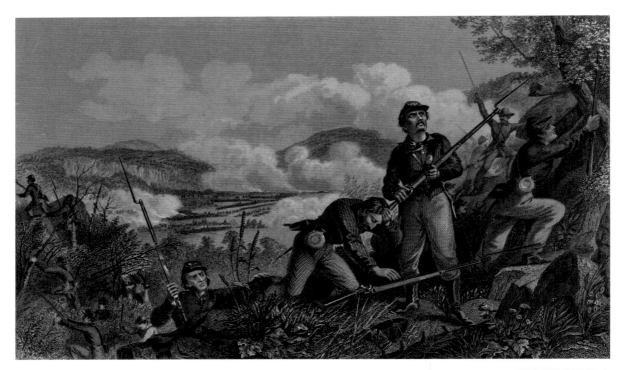

Fig. 115. The Battle of Lookout Mountain, lithograph.

Fig. 116. Lookout Mountain, Tennessee. The photograph captures a striking landscape—the sandstone summit high above the placid Tennessee River.

fog. By the afternoon, they had driven Confederate forces back, and Bragg ordered the Confederates to retreat. The following day, Federal forces stormed Missionary Ridge, routing the Confederates, ending the siege of Chattanooga, and opening routes into the Confederate interior. The dramatic landscape of Lookout Mountain, including its spectacular summit, captured the popular imagination. Soldiers, too, wanted to memorialize the Union victory in the

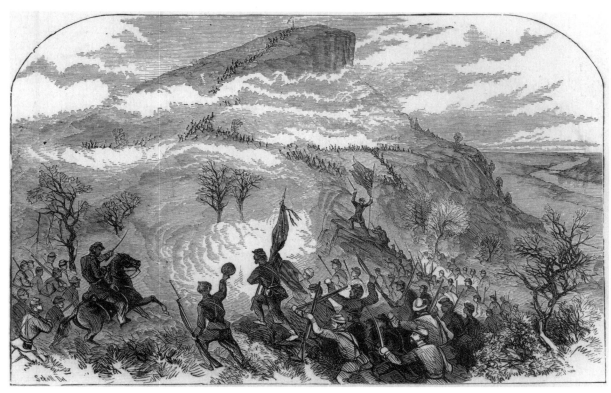

Fig. 117. The Battle of Lookout Mountain, engraving.

picturesque landscape (figs. 118, 119); even Ulysses S. Grant posed for a picture on the mountain (fig. 120).

As was the case at Chattanooga, the environment influenced military strategy and objectives in northwestern Georgia. On October 5, 1864, just over a month after the fall of Atlanta, Confederate general William Bell Hood attacked the Union supply line at a strategic point on the Western Atlantic Railroad at Allatoona Pass. The pass was a 360-foot cut through the Allatoona Mountains, fortified by the Federals. The fortifications proved effective, and the Union maintained its supply lines and its stores at the pass (figs. 121, 122).

Civil War photographers documented the impact of armies traversing diverse geography as well as the intersection of military service and civilian life. The Battle of Stones River occurred on December 31, 1862, and January 2, 1863, in central Tennessee. Along the river's bank, Federal soldiers, including African American men, stand for a picture (fig. 123). A man sits astride a horse, while three African American women and a child look toward the photographer from outside the double log cabin. The cabin was set in the middle of a cornfield—not uncommon in central Tennessee, a region that produced more corn than any other Confederate state east of the Mississippi. The cabin may have housed slaves, who made up close to half of the population in the vicinity of Murfreesboro, Tennessee. The photograph captures powerful forces at work in the western theater of the war. The protracted Union occupation of central Tennessee eroded slavery, as some African Americans fought for the Union and others provided crucial labor for the military. The images also highlight the ten-

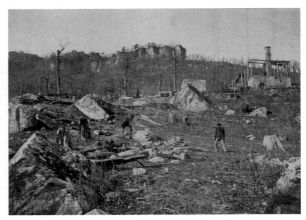

Figs. 118 and 119. Lookout Mountain, Tennessee. The photographs reveal the rock-strewn and barren terrain that soldiers fought over in the "Battle above the Clouds."

Fig. 120. Gen. Ulysses S. Grant with staff, Lookout Mountain, Tennessee. Grant poses, with his familiar cigar, at the summit, 1863.

Fig. 121. Allatoona Pass, Georgia, looking north. The fortifications are visible atop the heights while the railroad lines curve through the narrow pass. The stockpiled railroad ties and the hand-hewn, uneven ends of some testify to the army's constant vigilance in maintaining and repairing rail lines.

sion between the war's unpredictable course and the seasonal rhythms of rural, agricultural life.

Warfare disrupted efforts to extract, and profit from, the South's natural resources. The results were landscapes that were doubly altered. The structures that rose alongside waterways, fertile fields, and mineral deposits had altered the environment. The course of war reduced the buildings, halted human efforts to profit from nature, permanently in some places, temporarily in others.

Fig. 122. Allatoona Pass, Georgia, from the Etowah River. The sandbags used for fortifications to defend the railroad are visible in the foreground.

Fig. 123. Soldiers and civilians along the Stones River, near Murfreesboro, Tennessee.

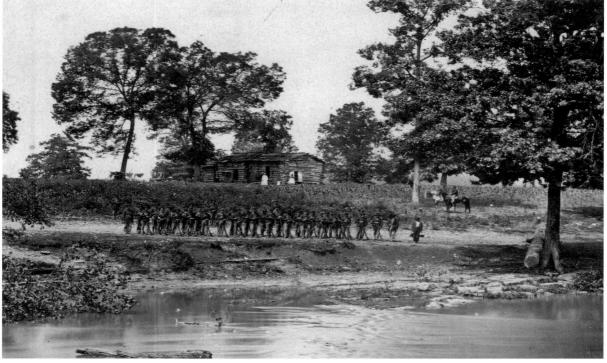

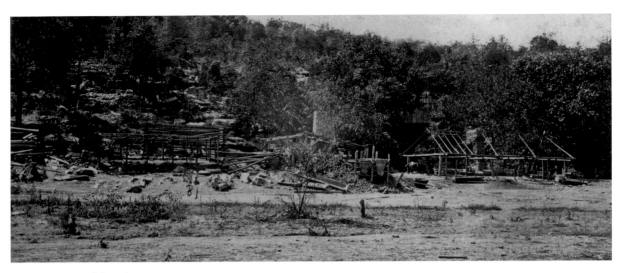

Fig. 124. Ruins of the salt-peter works, Nickajack Cave, Tennessee.

For example, just over twenty miles outside of Chattanooga, entrepreneurs had mined for saltpeter since the early nineteenth century, using the nitrogen for fertilizer and to manufacture gunpowder. The Confederacy placed the saltpeter works at Nickajack Cave under government control and extracted saltpeter until Union forces demolished the works in 1863 (fig. 124). Thereafter, visiting soldiers toured the cave and wrote of the extensive mining works that had been destroyed, including outdoor furnaces, internal filters, water tanks, and an extensive network of bridges. At Alisonia, Tennessee, the war's effect on the built environment was even more dramatic (fig. 125).

In 1860, the *Tennessee State Gazetteer and Business Directory* wrote of Alisonia: "A thriving post village of Franklin county, in the southern part of the State, situated on Elk river, and on the Nashville and Chattanooga railroad, a few miles north from Winchester, the capital of the county. 77 miles south south-east from Nashville, and 74 miles from Chattanooga. It was laid out in 1850, and is an important railway station, containing a large cotton manufactory, costing upwards of $100,000, and possesses superior water power, unsurpassed by any in the State."[5] By January 1864, a New York soldier wrote home from the Elk River that he had heard there was once a village called Alisonia, but not a house remained.[6]

When Richmond burned in the Confederate evacuation of April 1865, the Gallego Flour Mills were destroyed. The Gallego Mills were one of the nation's largest milling establishments. The images of the destroyed mills became popular at war's end and were reproduced as cartes de visite. For Americans, the war's cost could be measured not only in lives lost but also in environments transformed. Photographs of the ruins of Richmond documenting the destruction of the Confederate capital also proved popular cartes de visite after the war (fig. 126).

In the decades following the war, photography helped to fashion Civil War memory. A picture of the battlefield at Stones River in Tennessee illustrates

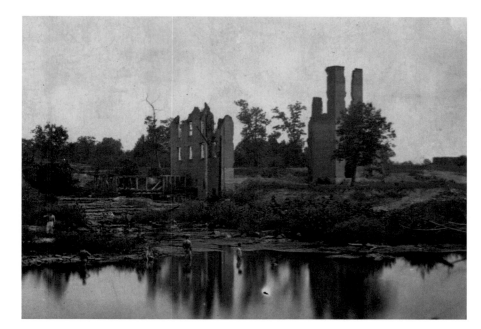

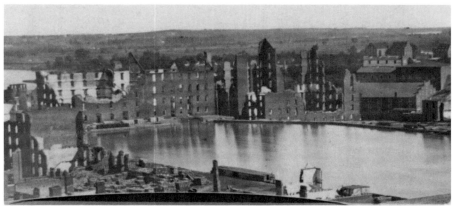

Fig. 125. Ruins of the Cotton Mill, Alisonia, Tennessee.

Fig. 126. Ruins of the Gallego Flour Mills, along the James River, Richmond, Virginia.

for postwar observers both agricultural renewal in the form of a cotton crop and African Americans' continued work in agriculture (fig. 127). Photographs also encouraged tourism. Visiting sites of the war; constructing lodging— such as the hotel looming above the field at Lookout Mountain; having one's picture taken near a battlefield; or purchasing a "photogravure," or retouched photograph, of the Observatory Road at Gettysburg bear witness to how Americans understood their own relationship to the Civil War landscape[7] (figs. 128, 129).

The view of the Observatory Road at Gettysburg after the war revealed an isolated wooded road that led to the observatory that was critical to Union forces on the first day of the battle. The image, a photogravure, was created by etching a copperplate with a photographic image (fig. 130). The process allowed for the mechanized reproduction of the images. In this case, E. B. Miller's image was printed by the New York Photogravure Company, a business that routinely included Civil War views in its offerings.

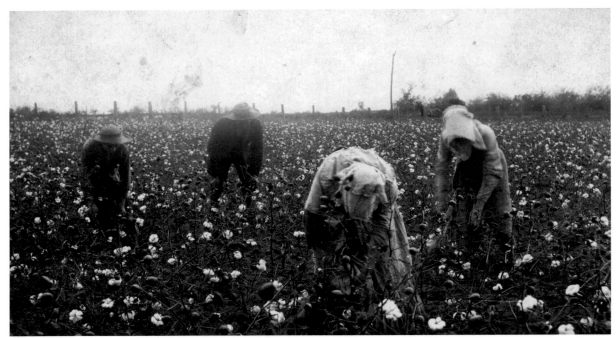

Fig. 127. Picking Cotton on the Stones River battlefield.

Fig. 128. Lookout Mountain, Tennessee. The Craven House hotel is located at the site of a Union charge and alongside a battlefield monument.

Fig. 129. Petersburg, Virginia, near the Friend House, with tourists.

Fig. 130. Gettysburg, Pennsylvania. The Observatory Road.

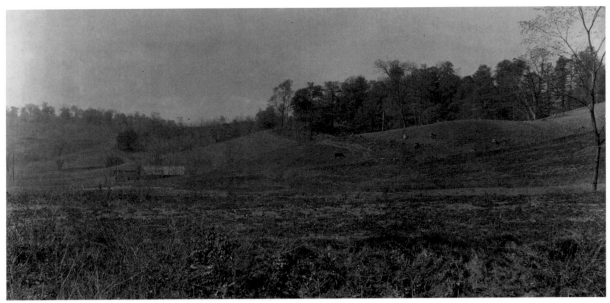

Fig. 131. Camp Dennison, Ohio. Site of J. D. Cox Jr.'s 1861 headquarters, in 1888.

Fig. 132. Camp Dennison, Ohio. Site of the Old Mill, 1888.

Fig. 133. Camp Dennison, Ohio. Valley of the Miami River, 1888.

On May 8, 1888, a photographer took images of the site of the former Camp Dennison. The photographs were owned by former Ohio governor J. D. Cox Jr. It is unknown whether he took the photographs himself (figs. 131, 132, 133). As a general in the war, Cox served in both the eastern and western theaters, and he was elected governor before he was mustered out of service. Following his term as governor, he served as secretary of the interior and as a railroad executive. When the photographs were taken, he was president of the University of Cincinnati. Close to three decades after the war, nature had covered the evidence of mobilization, and it was difficult to imagine the scene as it once appeared.

How Do You Want to Be Remembered?

In an article in the *Photographic News* that appeared the year after the war's end, a writer reflected on the role that photography had played in the war: "Photography has become a handmaiden to the present generation—a ministering angel to all conditions of life, from cradle to grave. An *aide-de-camp* of the loveliest character, to the great 'light of the world,' humanizing and elevating the minds of all, administering consolation to the sorrowing, increasing the joy of the joyous, lessening the pangs of separation caused by distance or death." The role of cartes de visite was especially significant, the writer noted. "The carte de visite form of picture became the 'rage' in America about the time the civil war commenced, and as the young soldiers were proud of their new uniforms, and those who had been 'in action' were prouder still of their stains and scars, the photographers did a good business among them, both in the city and in the camp."[1] By the close of the war, cartes de visite circulated so freely throughout the nation that the internal revenue office mandated that photographers affix revenue stamps to them.[2]

It was natural that a contributor to a photographic trade journal would argue for the importance of photography in American society. The language he used, however, indicated the complex role of photography and visual images in shaping public opinion about the war. In terms that placed photography in a feminized and domesticated space, the writer described its role as that of a handmaiden, or a female servant, that ministered, or nursed, from cradle to grave. The art of photography was militarized as an aide-de-camp, yet a particularly feminine one that humanized and elevated society in the same manner women did, according to nineteenth-century ideals of womanhood. Photography played an important role, therefore, in bringing war into

the domestic space of the home, alleviating distances, ameliorating the loss of human life, and providing a way for people to memorialize service and sacrifice. It did so, the writer observes, through the functions of the marketplace and fashion. Enterprising photographers provided an affordable means for images to be taken and transported through the mail, tapping a wartime market that would continue in the postwar years and include not only photographs but also albums, lithographs, and a wide array of printed ephemera.

Soldiers' letters confirm the role of photography in maintaining emotional connections between soldiers and their families. When Alfred Ely, a representative from New York, was captured by Confederates during the Battle of Bull Run and imprisoned in Richmond, the image of his daughter gave him strength. He recalled in his diary, published in early 1862, that on September 7, 1861, he received a letter from his wife in Rochester accompanied by a photograph of his daughter, Carrie. The picture was passed around to all the imprisoned officers, and he observed that it became "almost public property," which indicated the shared or communal nature of viewing photographs in nineteenth-century culture.[3] Henry Warren Howe, who enlisted in Lowell, Massachusetts, wrote home from Louisiana, fondly chiding one sister when her likeness did not meet his expectations, reporting favorably on the likeness of another, and sending images of himself and his fellow soldiers in return. Back in Lowell, his sister was charged with organizing "my collection" of images.[4] The soldier was not unique in his concern for collecting and preserving visual mementos of war. People purchased individual photographs as well as albums in which to display them in a practice of collecting and album-making that was a feature of American leisure. Album-making became more significant during and after the war when albums moved beyond their sentimental or edifying roles to bear witness to wartime contribution and sacrifice. Nurse Mary Livermore was said to have cherished, above all the tokens she received for her service, the fourteen photographic images of sick and wounded soldiers whom she had nursed.[5]

Amos Humiston's experience provides one of the most poignant examples of the ties between photography, the experiences of warfare, memory, and the marketplace. Humiston was a thirty-one-year-old harness maker when he enlisted in the 154th New York Infantry in the summer of 1862, leaving behind a wife and three children. A year later he fought on the first day of the Battle of Gettysburg and perished in a battle waged in the streets of the town. When his body was found, it lacked identification, but he was holding a picture of his three children. In the months that followed, a printer in Philadelphia made cartes de visite of the children's picture, and the press carried reports of the "Children of the Battlefield" and requested information about the soldier's identity. Humiston's wife came forward in November, but interest in the case continued. Humiston's death, with photograph in hand, was reinterpreted in *Frank Leslie's Illustrated Newspaper* in 1864, and proceeds from the sale of the picture funded an orphanage at Gettysburg.[6]

So pervasive and widely circulated were wartime photographs that in the immediate aftermath of the war, Northerners and Southerners framed the war's meaning relative to photographic images and helped shape the national understanding of the conflict's meaning for reconstituting the nation. For Herman Melville, the formal portrait of a Union officer reinforced conceptions of martial manhood, recalling classical virtue that formed bonds between the civilian observer, soldiers, and the war effort. For a woman in Lexington, Kentucky, graphic photographs of dead soldiers conveyed a message as well. "How my woman's heart / Thrills with convulsive pain / As I view, unrolled by magic art, / One dreadful scene from the battle-plain," she wrote shortly after the war, reflecting on the role of the camera in capturing the vivid image of death. Describing the degree of loss inspired by the image of the young Confederate soldier on "the trench-barred hill," she begged, "O Heaven! / spread o'er it thy merciful shield, / No more to my sight be the battle revealed! / Oh! fiercer than tempest, grim Hades as dread, / On woman's eye flashes the field of the dead." In the poem, the photograph is a conduit transmitting the death on the field of battle and the loss of life to the personal and domestic world of individual families and homes. The poem ends by turning from the photograph to the home, where a mother prays in vain for the soldier's safe return, "in a quiet room, / Far from the spot where the lone cor[p]se lies."[7] The image reinforced sentimentalism and the centrality of domestic life while recognizing the impersonal nature of death in barren trenches far from home.[8]

Photography shaped postwar political dialogue as well. Photographs of Union prisoners of war offered visual evidence of conditions in prison camps, inflaming the Northern public over Confederate treatment of prisoners and increasing calls for a punitive policy toward Southern civilians during the process of Reconstruction. One correspondent, writing for the *Philadelphia Enquirer* in the last days of the war, reported approvingly that a photographer was on hand in Richmond to take pictures of Libby Prison, including its prisoners.[9] So important was photography in documenting the impact of war that the Committee on the Conduct of the War ordered photographs taken of returned Union prisoners. Congressman Benjamin F. Wade of Ohio sent Lincoln some of the images, which would later be used as evidence in congressional hearings.[10]

A visitor to the United States, George Augustus Sala, wrote of a prisoner photograph displayed on Broadway in New York City, "We are bidden to look upon the portrait of a young man, very nearly naked—at least he might have been young, and a man, before he was converted into an anatomical preparation." The image and its public display clearly troubled him. The image, he writes, "serves political ends," and he observed that the photograph encouraged Northerners to dehumanize Southerners based on what may be, through such photographs, exceptional cases of the treatment accorded to Union soldiers in Confederate prisons. While acknowledging evidence of atrocities toward Union soldiers, Sala suggests it would be more reasonable to ascribe blame for the horrors of war to both sides. Notwithstanding Sala's concern

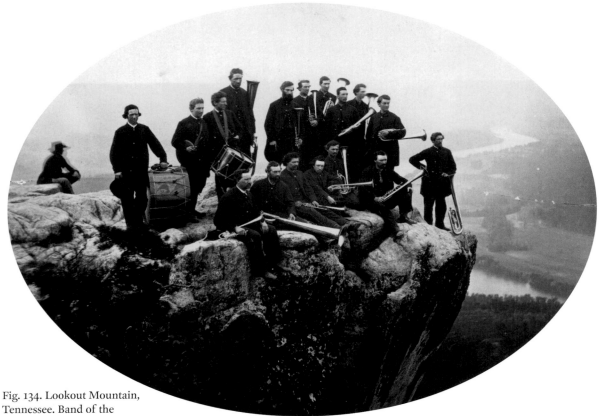

Fig. 134. Lookout Mountain, Tennessee. Band of the 2d Brigade, 3d Division, Twenty-third Army Corps, October 23, 1864.

over the use of photographs for purposes of propaganda, images of prisoners of war continued to shape Northerners' view of Confederates. In the trial of Henry Wirz for war crimes in the treatment of prisoners at Andersonville, the prosecution entered an image of prisoners into evidence. In August 1865, the army physician testified that the image represented "a fair picture of a Union prisoner who had been for some time in a rebel prison. I have seen hundreds of them—perhaps thousands. . . . [T]here were a great many of this character from Andersonville." On cross-examination, the surgeon testified on the skeletal image, "I think it represents a living person," and related he had seen "hundreds and hundreds" of images that were "quite the same."[11] The camera's lens was trained as well on notable subjects in the months following the war, including Wirz and the conspirators in Lincoln's assassination.[12]

In the decades following the war, portraits of individual soldiers or regiments became part of treasured collections. Jacob D. Cox Jr., an amateur collector who would be elected governor of Ohio in 1865, created his own album with cartes de visite of officers in his brigade. Professional collectors also emerged; these individuals often wrote to soldiers in their search for Civil War photographs. These collections would form the nucleus of archival collections throughout the United States. The interpretation of Civil War images shifted as well. For example, an 1895 New Hampshire magazine used Henry C. Moore's photographs of African Americans hoeing on Hopkinson's Planta-

tion on Edisto Island to illustrate "The Great Cause of War." The slaves themselves—not Southern political leaders, the Confederate military, or Southern civilians—were to blame for the war. Moore's best-known photograph of African Americans was distributed by the *Philadelphia Photographer* in 1865 with the title, "G'wine to de Field" and used to demonstrate a series of white assumptions: that blacks were reluctant to work in the absence of white owners, that blacks were suited for agricultural labor alone, and that blacks would, if left to choose, rather sleep and idle away their time than work industriously. Three decades later, as racial segregation became entrenched throughout the nation, the photograph was renamed, "Happy Days at Hilton Head," idealizing African Americans' labor in the prewar agricultural South.[13]

Throughout the war, photographers made profits by creating portraits of individuals or groups. The members of the band in the 2d Brigade, 3d Division, Twenty-third Army Corps posed for the dramatic group portrait at the top of Lookout Mountain in October 1864 (fig. 134).

Brig. Gen. Rufus Ingalls, serving as quartermaster, had his portrait taken in his wagon, accompanied by an African American boy, likely a servant (fig. 135). He would also pose with his horse and dog (fig. 136). Taken together, the presence of his servant, dog, horses, and carriage points to an officer conscious of his position, status, and race who chose to be remembered in a manner that employed trappings that were familiar to planters of the slave-owning aristocracy before the war.

John A. Rawlins, his wife, and child posed for the photographer at City Point, Virginia, and their image records evidence of domesticity amid the bustling military supply station (fig. 137). The presence of Rawlins's wife and child in the photograph testify as well to how families reordered their lives in response to war.

Fig. 135. Brig. Gen. Rufus Ingalls, quartermaster, in his wagon with African American boy, Alexandria, Virginia, 1865. Library of Congress.

Fig. 136. Brig. Gen. Rufus Ingalls poses with his horse and dog, Alexandria, Virginia, 1865. Library of Congress.

Fig. 137. Brig. Gen. John A. Rawlins and his family at Grant's headquarters, City Point, Virginia.

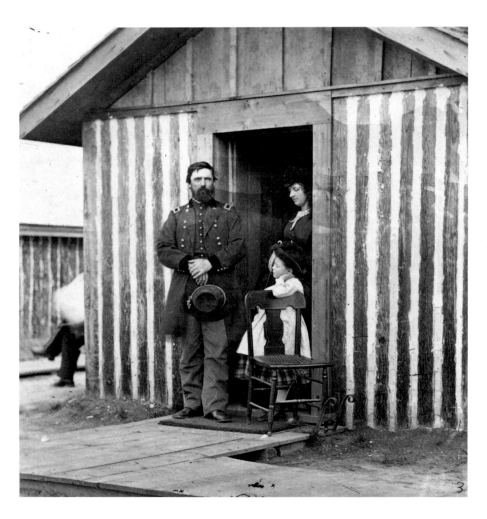

An unidentified woman posed with her husband and their horse outside a tent at Gettysburg (fig. 138). She annotated the photograph, identifying her husband and the horse she rode to the battlefield. Perhaps to divert the suspicions that would arise from the bottle in her husband's hand, she indicated that it was disinfectant. She also noted the iron bedstead and hospital stove in the tent, as well as the badge of the First Corps. The woman's possession of the photograph and careful inscription document her pride in her participation and her desire that her role at Gettysburg would be remembered.

After the war, the market for Civil War photographs continued, and the photographic supply house of E. and H. T. Anthony and Company capitalized swiftly on public interest. Beginning in the summer of 1865, they sold stereoscope images in a collection called, "Photographic History: The War for the Union." The series was popular and continued to sell into the 1870s. Among the images in the collection was a photograph of an African American woman standing outside the slave pen in Alexandria, Virginia (see fig. 12 on p. 13). Photography also documented living conditions of African Americans in the rural South. The meaning of such images was ambivalent; they could foster either sympathy or contempt in viewers. These photographs could also be deployed for political gain. Nineteenth-century Americans' response to the photo would vary depending on their levels of support for emancipation, racial equality, and

Fig. 138. Woman and her husband at Gettysburg, 1863.

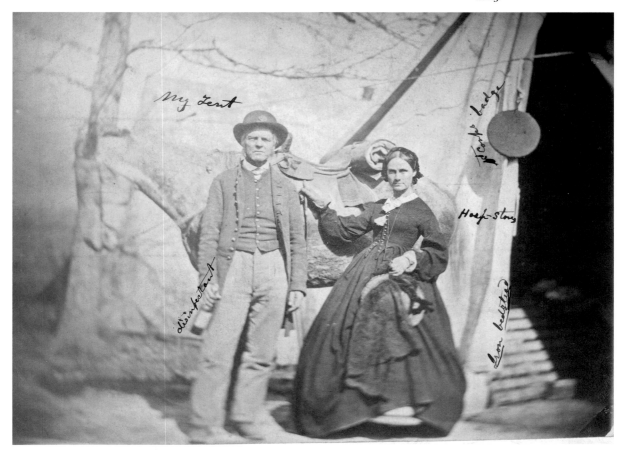

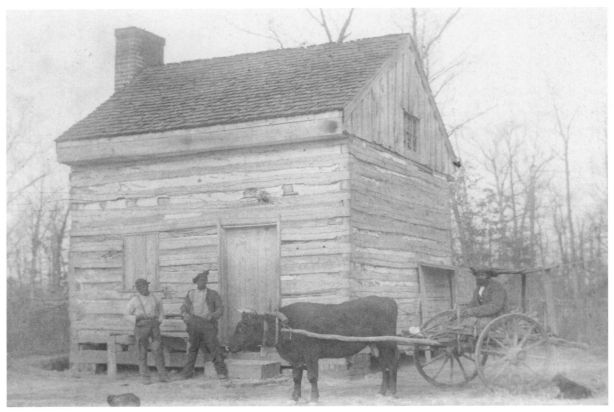

Fig. 139. African Americans, Virginia. Two men stand before the home, while a man poses in an oxcart.

Fig. 140. Abraham Lincoln's catafalque, Cleveland, Ohio.

women's status, but for modern viewers the photograph marks the distance traveled from slavery to freedom in four years of war (fig. 139).

Cartes de visite continued to play a role in how Americans understood the war. The small photographs served as mementos of important events, such as Lincoln's funeral procession from Washington, D.C., to Springfield, Illinois. Americans purchased photographs of Lincoln's catafalque in places like Cleveland, Ohio, and preserved the images in albums (fig. 140). Americans also collected images of family members, soldiers they had fought with, admired officers, attractive women, and the famous. The millions of photographs that survive provide a montage of images of Americans from the era, young and old, in dress uniforms or the modest raiment of a volunteer, against patriotic and classical backdrops, with gazes directed into the distance or directly at the viewer (figs. 141–152).

Orlando C. Risdon, like many Americans, enjoyed collecting such images. Risdon hailed from Summit County, Ohio, the son of a carpenter. When the war began, he worked as a farm laborer. He entered military service as a first lieutenant in the 47th Ohio Volunteer Infantry in 1861. He was wounded at Vicksburg in May 1863 and was appointed lieutenant colonel of the 3d Mississippi Regiment of Volunteers, which was raised among African Americans in Mississippi. The regiment would become the 53d United

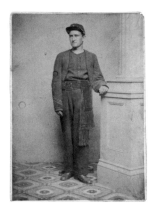
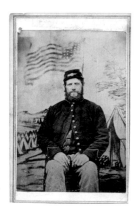
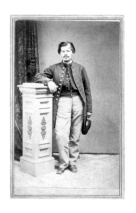
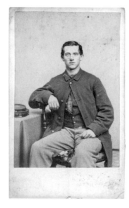
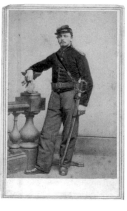

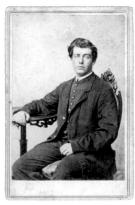
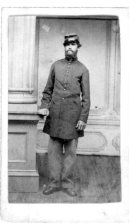

Figs. 141–152. Assorted cartes de visite.

States Colored Troop in 1864, and Risdon would rise to the rank of colonel of the regiment. He resigned in 1864 and, in the course of the next decade, relocated to Portage County, Ohio, and worked as a cheese manufacturer and then a grocer. Active in veterans' organizations, Risdon also compiled an album of officers in the Ninth Army Corps, which he preserved, along with his wartime accounts and papers.

Jacob D. Cox Jr., who documented the altered landscape at Camp Dennison, also created an album after the war, which contained cartes de visite of many of his staff (figs. 153–158). After the Battle of Antietam, Cox reported on the conduct of his staff:

Figs. 153–158. The Civil War album of Jacob D. Cox. Brigadier General J. D. Cox Jr.; Major W. W. Holmes, brigade surgeon; Medical Director Frink; Captain J. M. McElroy, assistant acting adjutant general; Captain M. D. W. Loomis, brigade quartermaster; Lieutenant J. W. Conine, aide-de-camp.

The General commanding takes this opportunity to mention the gallant and meritorious conduct of Captain G. M. Bascom, A.A.G.; Lieuts. S. L. Christie, J. W. Conine, and The. Cox, aidsde-camp [*sic*] on his personal staff; brigade Surgeon W. W. Holmes, for his thorough attention to the duties of the medical department, in the prompt organization of hospitals, and systematic provision for the wounded; Surgeon Cutter, late medical director on General Reno's staff, for energetic attention during the action to the disposal of the wounded in the field; also, to thank Captain E. P. Fitch, A.Q.M. and acting commissary of subsistence, for unwearied labor, by night as well as by day, in bringing forward supplies to the command under circumstances of great difficulty; also, to thank Mr. F. Cuthbert, a civilian, and employed in the quartermaster's department, for gallantry

Breg Genl J. D. Cox.

Maj. W. W. Holmes,
Brigade Surgeon.

Frink. Med. Direc.

Capt. J. M. McElroy,
A. A. A. Gen.

Capt. M. D. W. Loomis,
Brig. Qr. Master.

Lieut. J. W. Conine,
aide-de-camp.

Figs. 159–170. Charles D. Magnus cards.

displayed as a volunteer in carrying despatches and orders upon the field. The ability and gallantry displayed by the division commanders has already been noticed, in the official report of the engagement.[14]

The fashion for photograph albums extended to other consumer products as well. Lithographer and printer Charles D. Magnus utilized photographs and drawings to produce line drawings for printed materials adorned with patriotic images. During the war, Magnus produced stationery, sheet music, and bird's-eye lithographs of cities. After the war, his printing repertoire expanded to include certificates, games, valentines, and cards. Included among

these were collectors' cards depicting Confederate officers and government leaders. The popularity of this card collection reflected Americans' taste for collecting pictures of prominent people and the successful marketing of Civil War–related items to consumers who had become accustomed to bringing visual representations of the war into their homes (figs. 159–170).

In the decades after the war's end, photographic retailers and printers marketed decorative prints that responded to and shaped postwar memory. The print of a Union prison at Salisbury, North Carolina, was similar in its format to the popular lithographs of American cities, including the presence of a key to identify the dead house, the officers' houses, and a hole from which Union soldiers escaped (fig. 171). A print of a wartime prison rendered a place that was distant in both time and place to one more recognizable to Northern audiences. By showing the place where Union soldiers escaped, the print celebrates Union resistance to their Confederate captors. Many Americans would be familiar with the November 1864 escape attempt at the prison that resulted in Confederates turning cannon fire on the prisoners, as the episode had been reported in the Northern press. The printer was careful to authenticate the image by marking it as a replica of a painting made in 1864, which added credibility and legitimacy to a product that was marketed in 1886 by J. H. Bufford's Sons of Boston, New York, and Chicago.

A lithograph of Andersonville Prison was published in 1868 depicting the infamous prison camp with information available in a key, similar to that in the Salisbury prison print, including the dead house (fig. 172). The Andersonville image also contained an identified dead line, the latrine running through

Fig. 171. Bird's-eye view of a Confederate prison pen, Salisbury, North Carolina.

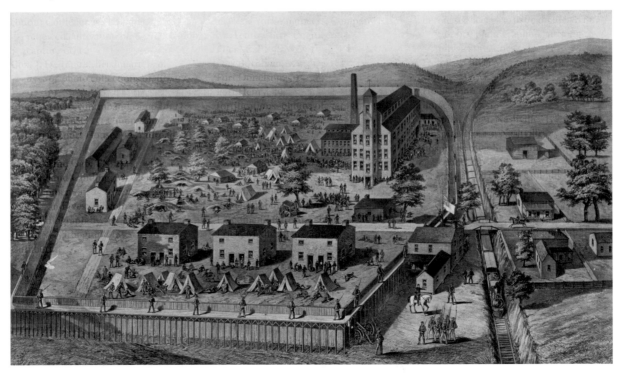

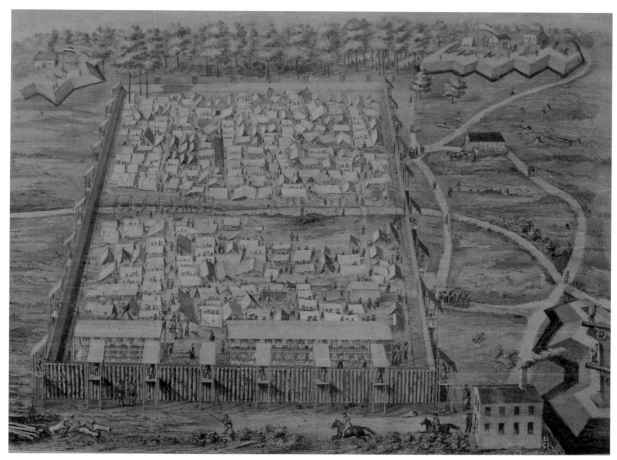

Fig. 172. Bird's-eye view of Andersonville Prison, Georgia.

the camp, and the added embellishment of sentries firing at prisoners and a pack of dogs attacking an escaping prisoner in the foreground. In reality, although there were as many as 33,000 Union prisoners at Andersonville in the summer of 1864, few prisoners escaped from the remote prison camp, while close to one-third of the prisoners perished in camp.[15] The graphic image of Andersonville Prison was purchased by Americans and displayed in their homes, seen as parlor curiosities, as maps of a wartime landscape described in the press and in memoirs, or as reminders of Confederate atrocities that shaped postwar politics toward the South.

Lithographs also served to romanticize the war and appeal to conventions of domesticity and gender. The lithograph "Little Hero" was produced by Kellogg and Bulkeley of Hartford, Connecticut, after 1871 (fig. 173). The colorful rendering of a little girl playing soldier recalls images of children playing at war in illustrated magazines such as *Harper's Weekly* during the war. The explicit feminization of military play, confined within the parlor, shows a shift toward artistic renderings of the family's wartime experience that were sentimental, entertaining, and idealized.

The Currier and Ives lithograph "The Soldier's Grave" provided space for families to write in the name of the deceased soldier, thus personalizing

Fig. 173. The "Little Hero."

the image (fig. 174). The lithograph could memorialize those lost in the war whose bodies were never recovered, which denied their families the important mourning ritual of visitation. Moreover, the image domesticated death through the mourning wife or mother while simultaneously sustaining Union patriotism through the flags and shields adorning the headstone and through the image of departing soldiers. The weeping willow trees and garden flowers symbolized nineteenth-century Americans' view of death as a natural process that generated spiritual rebirth.[16]

In the decades that followed the war, its meaning was reshaped and redefined through visual images. Under the 1868 Reconstruction constitution of South Carolina, African Americans made up a majority in the state legislature,

Fig. 174. "The Soldier's Grave." Currier and Ives lithograph.

and affordable access to photography meant that the public became familiar with the image of black politicians. One photographic collage incorporated portraits of black Republican legislators above a heading, "Radical Members of the So. Ca. Legislature," in a crude representation of black politicians as tools of Radical white legislators (fig. 175).

Public discomfort with the racial and political legacy of the war was played out in images that featured former slaves in passive roles, heralding the Union soldiers who fought for "Government, the Union and the Constitution of the United States." The lithographic certificate pictured here defined the war's purpose and its legacy, allowing individuals to sign their name and certify themselves as "Union Defenders" (fig. 176). In a postwar North that struggled over

Fig. 175. "Radical Members" of the South Carolina Legislature. Carte de visite.

Fig. 176 (facing page). The Union Defenders certificate.

extending suffrage to African American men and viewed black political influence in the Southern states with unease, being a Union defender constituted a patriotism that was devoid of concerns for racial justice and infused with confidence in the power of government. By the turn of the twentieth century, visual representations of African Americans would overwhelmingly sustain ideas of innate racial inferiority and passivity while celebrating (white) military valor on both sides of the war, which created new bonds that drew a nation toward a segregated future.

NOTES

INTRODUCTION

1. Zeller, *Blue and Gray in Black and White*, 2.
2. Morrow, "Birth of Photojournalism," 40–46; Morton Keller, *The World of Thomas Nast*, http://cartoons.osu.edu/nast/keller_web.htm.
3. Sandler, *Photography*, 39–42.
4. Trachtenberg, "Albums of War: On Reading Civil War Photographs," 5–6; Sandler, *Photography*, 7–17. The stereoscope in the front room of the Abraham Lincoln home is an authentic piece of the period that has a plausible provenance of belonging to Lincoln. See www.nps.gov/history/history/online_books/liho/sectiond-f.htm. Much has been written on the photographs of Abraham Lincoln. For one example of the importance of the photograph in the campaign, see William D. Kelley's letter to Norman B. Judd, June 1, 1860, in "Abraham Lincoln Papers," ser. 1, General Correspondence, 1833–1916, Library of Congress; and Havery G. Eastman to Abraham Lincoln, April 7, 1860, in Basler, Pratt, and Dunlap, eds., *Collected Works of Abraham Lincoln*, 4:40. Mathew Brady's photograph of Lincoln when the president visited New York City to give his Cooper Union address was reproduced in *Harper's Weekly*. A February 1865 sitting by Lincoln produced a stereoscope card. See also Holzer, "Photograph That Made Lincoln President," 24–33.
5. Morrow, "Birth of Photojournalism," 40–46; Zeller, *Blue and Gray in Black and White*, 27–28.
6. Youngblood and Bonds, *Mathew B. Brady*, 8–22.
7. *Transactions of the Western Reserve Historical Society* (Oct. 1920): 54–55; "Selected Civil War Photographs, 1861–1865," Prints and Photographs Division, Library of Congress, http://memory.loc.gov/ammem/cwphtml/cwdes.html (accessed Dec. 28, 2010).

1. SELLING THE WAR: THE BUSINESS OF PHOTOGRAPHY

1. Sandler, *Photography*, 107.
2. *Humphrey's Journal of the Daguerreotype and Photographic Arts* 13 (Sept. 1, 1861): 143–44 (hereafter cited as *Humphrey's Journal*).
3. Zeller, *Blue and Gray in Black and White*, 21.
4. *Humphrey's Journal* 13 (Sept. 15, 1861): 159.
5. *Philadelphia Inquirer*, Feb. 18, 1861; Zeller, *Blue and Gray in Black and White*, 35–40, 43–44; Teal, *Partners with the Sun*, 88–89, 93.
6. *New Orleans Picayune*, May 24, 1861.
7. Zeller, *Blue and Gray in Black and White*, 49–50.
8. *New Hampshire Patriot and State Gazette* (Concord), Sept. 5, 1855.
9. Morrow, "Birth of Photojournalism," 40–46.

10. See Bolster and Anderson, *Soldiers, Sailors, Slaves and Ships,* 17.

11. Holmes, "Doings of the Sunbeam," 11–12.

12. *New York Times,* Oct. 20, 1862.

2. ORDERING WAR

1. Peters and Mergen, "'Doing the Rest,'" 280–303.

2. *New York Times,* May 17, 1861.

3. Schein, "Representing Urban America," 11; Reps, *Views and Viewmakers of Urban America,* 4–7.

4. Hurst, *Journal-history of the Seventy-third Ohio Volunteer Infantry,* 10–11.

5. Wilder, *History of Company C, Seventh Regiment O.V.I.,* 43.

6. *Harper's Weekly,* June 11, 1864.

7. Harrison, "Belle Plain and 'the Punch Bowl' in 1864."

8. Hawk, "Ambulance Train," 197–219.

9. Bacon and Howard, *Letters of a Family during the War for the Union,* 479–80, 495–96.

10. United States War Department, *Report of the Secretary of War Which Accompanied the Annual Message of the President of the United States,* 67–72.

11. United States Sanitary Commission, *Sanitary Commission of the United States Army,* 234–36.

12. Powers, *Hospital Pencillings,* 119–52.

13. Whitman, "Army Hospitals and Their Cases," 825–30.

14. C. H. Steadman to G. H. Gay, Sept. 7, 1862, in *Report to William J. Dale, Surgeon General of Massachusetts.*

15. *Boston Medical and Surgical Journal* 68 (1863): 219.

16. Cook, *Siege of Richmond,* 220.

17. Woodward, *Reports on the Extent and Nature of the Materials Available,* 26.

18. McPherson, *Battle Cry of Freedom,* 732–33.

3. TO SUPPLY AND SUSTAIN THE TROOPS

1. Wilson, *Business of Civil War,* 1–2, 57.

2. Hagerman, *American Civil War and the Origins of Modern Warfare,* 36–69.

3. Ibid., 151–74.

4. Thorndike, *Sherman Letters,* 132, 135, 136, 240.

5. United States War Department, *Annual Report of the Secretary of War,* pt. 2, no. 7, 261–98.

6. "The Government Bakery," *Scientific American,* Sept. 1863, 167.

4. SEEING THE LAND: IMAGES OF WAR AND LANDSCAPE

1. Schein, "Representing Urban America," 7–21.

2. *Philadelphia Inquirer,* Dec. 30, 1862.

3. Faust, "Civil War Soldier and the Art of Dying," 3–38; Bushnell, "Oration: Our Obligations to the Dead," 338. Also, Faust, "Civil War Soldier and the Art of Dying," 24, quoted in Wilson, "Winslow Homer's 'The Veteran in a New Field,'" 2–4.

4. Ellis, *Leaves from the Diary of an Army Surgeon,* 275–76.

5. Mitchell, *Tennessee State Gazetteer and Business Directory for 1860–61,* 6.

6. R. Cruikshank letter, Jan. 15, 1864, available at www.salem-ny.com/1864letters.html (accessed June 22, 2010).

7. Hoelscher, "Photographic Construction of Tourist Space in Victorian America," 548–50.

1. *Photographic News,* Jan. 12, 1866, 16–17.

2. *(Baltimore) Sun,* May 5, 1865.

3. Lanman, *Journal of Alfred Ely,* 105–6.

4. Howe, *Passages from the Life of Henry Warren Howe,* 40, 130, 132, 159, 166.

5. Brockett, *Mary C. Vaughan,* 589.

6. Zeller, *Blue and Gray in Black and White,* 113–18.

7. F. F., Lexington, Ky., "Lines Written on Seeing a Photograph," in Mason, *Southern Poems of the War,* 416–17.

8. For the family and domesticity during the war, see Rose, *Victorian America and the Civil War,* 145–92.

9. *Philadelphia Inquirer,* Apr. 10, 1865.

10. Benjamin F. Wade to Abraham Lincoln, Friday, May 20, 1864, Abraham Lincoln Papers, Library of Congress.

11. Sala, *My Diary in America in the Midst of War,* 319–25; Trial of Henry Wirz, 86.

12. *Washington Daily Constitutional Union,* July 8, 1865; *Philadelphia Inquirer,* Sept. 11, 1865.

13. Linchan, "War Pictures," 343–50. See also Bolster and Anderson, *Soldiers, Sailors, Slaves and Ships,* 81.

14. Cox, "Special Orders No. 8, September 28, 1862," 466.

15. Davis, "Escape from Andersonville," 1065–82.

16. Faust, *Republic of Suffering,* 211–49.

BIBLIOGRAPHY

Adams, Sean P. "Promotion, Competition, Captivity: The Political Economy of Coal." *Journal of Policy History* 18, no. 1 (2006): 82–83.

Bacon, Georgeanna Woolsey, and Eliza Woolsey Howard, eds. *Letters of a Family during the War for the Union, 1861–1865.* 2 vols. New Haven, Conn.: Tuttle, Moorehouse and Taylor, 1899.

Basler, Roy P., Marion Dolores Pratt, and Lloyd A. Dunlap, eds. *The Collected Works of Abraham Lincoln*, vol. 4. New Brunswick, N.J., Rutgers Univ. Press, 1953.

Bolster, W. Jeffrey, and Hilary Anderson. *Soldiers, Sailors, Slaves and Ships: The Civil War Photographs of Henry P. Moore.* Concord: New Hampshire Historical Society, 1999.

Brockett, Linus Pierpont. *Mary C. Vaughan: Woman's Work in the Civil War.* Philadelphia: n.p., 1867.

Bushnell, Horace. "Oration: Our Obligations to the Dead." In *The Commemorative Celebration held at Yale College,* Wednesday, July 26, 1865, 319–55. New Haven, Conn.: n.p., 1866.

Cook, Joel. *The Siege of Richmond.* Philadelphia: George W. Childs, 1862.

Cox, J. D. "Special Orders No. 8, September 28, 1862." In *The Rebellion Record: A Diary of American Events for 1862,* vol. 5, edited by Frank Moore, 466. New York: G. P. Putnam and Son, 1863.

Davis, Robert Scott. "Escape from Andersonville: A Study in Isolation and Imprisonment." *Journal of Military History* 67 (Oct. 2003): 1065–82.

Davis, William C., ed. *The Image of War, 1861–1865.* New York: Doubleday and Co., 1984.

Ellis, Thomas T. *Leaves from the Diary of an Army Surgeon.* New York: John Bradburn, 1863.

Faust, Drew Gilpin. "The Civil War Soldier and the Art of Dying." *Journal of Southern History* 67 (Feb. 2001): 3–38.

———. *This Republic of Suffering: Death and the American Civil War.* New York: Alfred A. Knopf, 2008.

Fralin, Frances. *The Indelible Image: Photographs of War—1846 to the Present.* New York: Harry N. Abrams, 1985.

Frassanito, William A. *Antietam: The Photographic Legacy of America's Bloodiest Day.* New York: Charles Scribner's Sons, 1978.

———. *Gettysburg: A Journey in Time.* New York: Charles Scribner's Sons, 1974.

———. *Grant and Lee: The Virginia Campaigns, 1864–1865.* New York: Charles Scribner's Sons, 1983.

Gardner, Alexander. *Gardner's Photographic Sketchbook of the Civil War.* Reprint. New York: Dover, 1959.

Hagerman, Edward. *The American Civil War and the Origins of Modern Warfare.* Bloomington: Indiana Univ. Press, 1988.

Harrison, Noel G. "Belle Plain and 'the Punch Bowl' in 1864." *Military Images* (July–Aug. 2000): 1–7.

Hawk, Alan. "The Ambulance Train, or How the Hospital Train Transformed Army Medicine." *Civil War History* 4 (Sept. 2002): 197–219.

Heiskell, Joseph Brown. *Reports of Cases Argued and Determined in the Supreme Court of Tennessee for the Eastern Division 1870.* Vol. 1. Nashville: Jones, Purvis and Co., 1870.

Hoelscher, Steven. "The Photographic Construction of Tourist Space in Victorian America." *Geographical Review* 88 (Oct. 1998): 548–50.

Holmes, Oliver Wendell. "Doings of the Sunbeam." *Atlantic Monthly,* July 1863, 11–12.

Holzer, Harold. "The Photograph That Made Lincoln President." *Civil War Times* 45 (Nov.–Dec. 2006): 24–33.

Howe, Henry Warren. *Passages from the Life of Henry Warren Howe.* Lowell, Mass.: Courier Citizen Company, 1899.

Hurst, Samuel H. *Journal-history of the Seventy-third Ohio Volunteer Infantry.* Chillicothe, Ohio: n.p., 1866.

Katz, D. Mark. *Witness to an Era: The Life and Photographs of Alexander Gardner.* New York: Viking, 1991.

Kelbaugh, Ross J. *Directory of Civil War Photographers.* Baltimore, Md.: Historic Graphics, 1990.

Keller, Morton. *The World of Thomas Nast.* http://cartoons.osu.edu/nast/keller_web.htm.

Lanman, Charles, ed. *The Journal of Alfred Ely.* New York: D. Appleton, 1862.

Lewinski, Jorge. *The Camera at War: A History of War Photography from 1848 to the Present Day.* New York: Simon and Schuster, 1980.

Linchan, John C. "War Pictures." *Granite Monthly* 18 (June 1895): 343–50.

Marder, William, and Estelle Marder. *Anthony: The Man, the Company, the Camera.* Plantation, Fla.: Pine Ridge, 1982.

Mason, Emily Virginia, ed. *The Southern Poems of the War.* 2nd ed. Baltimore: John Murphy, 1868.

McPherson, James M. *Battle Cry of Freedom.* New York: Oxford Univ. Press, 1988.

Melville, Herman. "On the Photograph of a Corps Commander." In *Battle-Pieces and Aspects of the War.* New York: Harper and Brothers, 1866.

Miller, Francis Trevelyan. *The Photographic History of the Civil War.* New York: T. Yoseloff, 1910.

Mitchell, John L. *Tennessee State Gazetteer and Business Directory for 1860–61,* no. 1. Nashville: John L. Mitchell, 1860.

Morrow, Kevin. "The Birth of Photojournalism." *Civil War Times* 46 (Sept. 2007): 40–46.

Peters, Marsha, and Bernard Mergen. "'Doing the Rest': The Uses of Photographs in American Studies." *American Quarterly* 29, no. 3 (1977): 280–303.

Powers, Elvira J. *Hospital Pencillings.* Boston: Edward L. Mitchell, 1866.

Report to William J. Dale, Surgeon General of Massachusetts. Boston: Surgeon General's Office, 1862.

Reps, John William. *Views and Viewmakers of Urban America: Lithographs of Towns and Cities in the United States and Canada.* Columbia: Univ. of Missouri Press, 1984.

Rose, Anne C. *Victorian America and the Civil War.* New York: Cambridge Univ. Press, 1992.

Russell, Andrew J. *Russell's Civil War Photographs.* New York: Dover, 1982.

Sala, George Augustus. *My Diary in America in the Midst of War.* Vol. 2. London: Tinsley Brothers, 1865.

Sandler, Martin W. *Photography: An Illustrated History.* New York: Oxford Univ. Press, 2002.

Schein, R. H. "Representing Urban America: Nineteenth-Century Views of Landscape, Space, and Power." *Environment and Planning D: Society and Space* 11 (1993): 7–21.

"Selected Civil War Photographs, 1861–1865." Prints and Photographs Division, Library of Congress. http://memory.loc.gov/ammem/cwphtml/cwdes.html.

Sweet, Timothy. *Traces of War: Poetry, Photography, and the Crisis of the Union.* Baltimore: Johns Hopkins Univ. Press, 1990.

Teal, Harvey S. *Partners with the Sun: South Carolina Photographers, 1840–1940.* Columbia: Univ. of South Carolina Press, 2001.

Thorndike, Rachel Sherman, ed. *The Sherman Letters: Correspondence between General and Senator Sherman from 1837 to 1891.* New York: Charles Scribner's Sons, 1898.

Trachtenberg, Alan. "Albums of War: On Reading Civil War Photographs." *Representations* 9 (Winter 1985): 5–6.

———. *Reading American Photographs: Images as History, Mathew Brady to Walker Evans.* New York: Hill and Wang, 1989.

Trial of Henry Wirz. Letter from the Secretary of War ad interim. 40th Congress, 2d session, House Executive Document 23. Washington, D.C., 1866.

United States Sanitary Commission. *The Sanitary Commission of the United States Army: A Succinct Narrative of Its Works and Purposes.* New York: n.p., 1864.

United States War Department. *Annual Report of the Secretary of War,* part 2, no. 7. Washington, D.C.: Government Printing Office, 1866.

———. *Report of the Secretary of War Which Accompanied the Annual Message of the President of the United States.* Washington, D.C.: Government Printing Office, 1863.

Whitman, Walt. "Army Hospitals and Their Cases, Memoranda at the Time, 1863–1866." *Century Illustrated Magazine,* Oct. 1888, 825–30.

Wilder, Theodore. *The History of Company C, Seventh Regiment O.V.I.* Oberlin, Ohio: n.p., 1866.

Wilson, Christopher Kent. "Winslow Homer's 'The Veteran in a New Field': A Study of the Harvest Metaphor and Popular Culture." *American Art Journal* 17 (Autumn 1985): 2–4.

Wilson, Mark R. *The Business of Civil War: Military Mobilization and the State, 1861–1865.* Baltimore: Johns Hopkins Univ. Press, 2006.

Witham, George F., comp. *Catalogue of Civil War Photographers: A Listing of Civil War Photographers' Imprints.* Portland, Ore.: G. F. Witham, 1988.

Woodward, Joseph Janvier. *Reports on the Extent and Nature of the Materials Available for the Preparation of a Medical and Surgical History of the Rebellion.* Philadelphia: J. B. Lippincott and Co., 1865.

Youngblood, Wayne, and Ray Bonds. *Mathew B. Brady.* London: Compendium, 2008.

Zeller, Bob. *The Blue and Gray in Black and White: A History of Civil War Photography.* Westport, Conn.: Praeger, 2005.